NEW JERSEY
FRESH

RACHEL WESTON

NEW JERSEY
FRESH

FOUR SEASONS
FROM FARM TO TABLE

AMERICAN PALATE

Published by American Palate
A Division of The History Press
Charleston, SC 29403
www.historypress.net

Front cover image of peach pie courtesy of Rose Robson. Back cover images of farmer couple by Gabby Aron and peaches by Rose Robson. Other cover images by author. Internal images courtesy of author unless otherwise noted.

First published 2015

Manufactured in the United States

ISBN 978.1.62619.978.1

Library of Congress Control Number: 2015932378

Notice: The information in this book is true and complete to the best of our knowledge. It is offered without guarantee on the part of the author or The History Press. The author and The History Press disclaim all liability in connection with the use of this book.

For all the men and women who choose to turn their backs to the sun every day to tend to the earth so the rest of us may eat.

Contents

CONTENTS

Acknowledgements

Thanks to Pegi Adam of the New Jersey Peach Promotion Council; Gabby Aron; Mikey Azzara at Zone 7; Faith Bahadurian, for connecting me with this opportunity to write a book about food in New Jersey; Diane Biancamano at Gail Schoenberg PR; Warren Bobrow; Nancy Boone at Ramsey Farmers' Market; Debra Burns, for encouraging me to listen to my voice and generously providing feedback and editing; Mark Canright at Comeback Farm; Chris Cirkus at West Windsor Community Farmers' Market; Jennifer Lea Cohan at Savory PR; Beth Feehan, director of New Jersey Farm to School Network; Lisanne Finston, for believing in me and being the best boss ever; Whitney Landis, my commissioning editor, and Ryan Finn, my project editor, at The History Press; Enrique Lavin, for taking a chance on me and giving me a food column in the *Star-Ledger*; Vicki Hyman, for her insights and wit as my editor there; photographer Saed Hindash, for making me look good; David Hodges at Collingswood Farmers' Market; Theresa Lam; Matt and Ted Lee, for helping me narrow the concept for this book and the next; John D. Mason, my literary attorney; Camille Miller, executive director of NOFA-NJ; the New Jersey Farm Bureau; Jess Niederer at Chickadee Creek Farm; Rich Norz, president of the New Jersey State Board of Agriculture; the staff of the Ocean Township branch of the Monmouth County Library, for fulfilling my endless cookbook requests; Elizabeth Reynoso, food policy director for Newark, NJ; Rose Robson at Robson's Farm; Karen Schloss Diaz and Teresa Akersten at Diaz Schloss Communications; Steven Shomler, fellow History Press author; Slow

Food Central New Jersey; Catherine Suttle at Hunterdon Land Trust; Steve Tomlinson at Great Road Farm; Bill Walker at the New Jersey Department of Agriculture; Vegetable Growers Association; Nirit Yadin; and the restaurants that contributed recipes herein: Agricola, A Toute Heure, the Orange Squirrel, Órale Mexican Kitchen, Porta, Tre Piani, Samba, Satis Bistro, Spuntino's Wine Bar and Italian Tapas and WildFlour Bakery Café.

Thanks to my friends Joan E. Brown, Jacquelyn Juricic, Armando Miranda, Cynde McKernan, Toni Misthos, Janice Pritchett, Sandy Soriano and everyone else who has endured my social absences, listened to my endless produce stories, taste-tested my recipes and supported me during the making of this book.

Thanks to my family: my mother, Leslie Wood; my father, Wade French; my sister, Carey French; great-grandmother Lois Mason; grandparents Bradner and Gertrude Wood; Bradner Wood II; Michael and Linda French; Leonard and Carlie Raulerson; Terry Louderback; Mike Luscz; my in-laws, Harvey and Debra Weston; and my husband, Shawn Weston, without whose unwavering love, support and encouragement none of this would have been possible.

Note: Portions of the content included in this book were previously published on NJ.com.

Introduction

We all need to eat. That's the truth. In our society built for convenience and innovation, our primary goal is to be able to get dinner on the table every night. We get bonus points for keeping up with the hot food trends, but in reality, trendiness isn't necessary.

"Local food-sourcing is the only trend that ever was and always will be," said Bill Walker of the New Jersey Department of Agriculture. "You can spin Asian or French or anything else, but it all gets down to the quality of your input ingredients."

I couldn't agree more. I am able to eat year-round mainly using products grown right here in the Garden State. My commitment to eating what is available and curiosity for how global cuisines approach the same ingredient, such as the tomato, is the basis for how I decide what's for dinner at my house. I shared my enthusiasm for this topic in my weekly "In Season" columns for NJ.com and at cooking classes around the state. My goal is to get everyone excited, not only about eating local but about getting into the kitchen to cook, too.

JERSEY FRESH

Bill Walker is a tireless advocate for Jersey Fresh, a thirty-year-old New Jersey Department of Agriculture program that helps build consumer

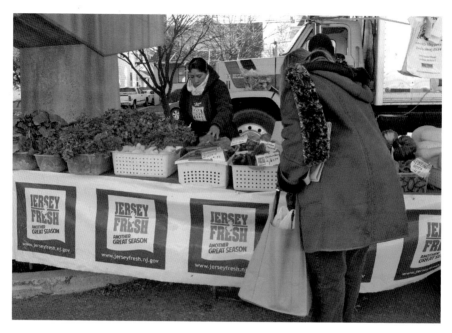

Jersey Fresh produce is sold by Flaim Farms from Vineland.

awareness about availability of fruits and vegetables grown in the state. When you see its iconic red and green logo on a farmer's products, you know exactly what you are getting—produce that tastes better because it was harvested at the peak of ripeness and made available for sale within hours or days of harvest.

This book is not affiliated with the program, although I am a firm supporter of its mission. Visit the Jersey Fresh website for resources on where to find farms, markets and seasonal availability information.

Know Your Farmer

How do you know what is in season? A good way to start is to get to know a farmer. All the farmers I know are more than willing to share information about how they grow their crops, why they favor a particular variety and how to make the most of it.

Rich Norz, president of the New Jersey State Board of Agriculture and owner of Norz Hill Farm in Hillsborough, shared his observations as

are available for three or four seasons. Others, such as broccoli and cabbage, may pop up in spring and fall. I grouped them where I feel they are most appropriate and also to give each season a comparable amount of options. Use the table of contents or the index to quickly find your way around.

GET STARTED

You will need an appetite, a taste for adventure and a minimal amount of kitchen equipment to get started. Cooking should be fun. Choose quality ingredients grown by people in your own community and get in the kitchen. It's that easy. Happy cooking!

income families and senior citizens. Many markets offer music, cooking demonstrations, children's activities and opportunities to interact with community organizations. The wide variety in programming and locations makes it worthwhile to take a little road trip to visit markets across the state. Every day of the week, markets are happening. With their growing popularity, many markets are extending the season by moving indoors during the winter months.

Let Me Be Your Guide

Keep this book in your market bag. When you spot something you aren't quite sure what to do with, instead of leaving it on the farmer's table, flip open the book, make a game plan and feel good about making a well-informed purchase.

It should also be a valuable resource for anyone who participates in a community shared agriculture (CSA) program. CSA members buy-in with a farm at the beginning of the season and receive a weekly share of produce once crops become available. The quantity and variety of produce in a share can be overwhelming. When you receive an e-mail from the farm outlining what to expect for the week, simply find your ingredients in this book and plan your menu.

I've included references to cookbooks I have found to be invaluable and websites I turn to regularly for recipe ideas. There are also a dozen recipes from noted chefs around the state to inspire you all year long.

Organization

There are more than fifty produce profiles collected here in four seasonal groups: spring, summer, fall and winter. Although I could have arranged the entire list alphabetically, I chose not to do that to really emphasize the joy that comes with eating in-season.

For shoppers most acquainted with the supermarket, seasonality can be a little fuzzy. Strawberries may be at the grocer's 365 days a year, but they are actually only in season here in New Jersey for a very brief time from late spring to early summer. Some crops, such as beets, leafy greens and radishes,

VISIT A FARMERS' MARKET

Bill Walker told me that the popularity of farmers' markets has exploded. In the last fifteen years, the number of markets has grown tenfold. Starting with about 15 markets in 2000, there are now close to 150 to choose from around the state. "Everybody wants to create a sense of community in their town. These things help do that. They help downtown revitalization, and it gives people the opportunity to join under something that benefits their neighbors and their town. These markets mean something different in every town," he said.

Just as the produce you find there will vary, there are differences in the markets, too. Locations range from historic farms such as the Burlington County Farmers' Market to bustling downtown city locations in Newark and Trenton, empty commuter parking lots, school cafeterias, public parks and a few close enough to the ocean to smell the salt in the air.

The majority of markets include farmers who accept WIC and senior FNMP vouchers that provide access to fresh fruits and vegetables for low-

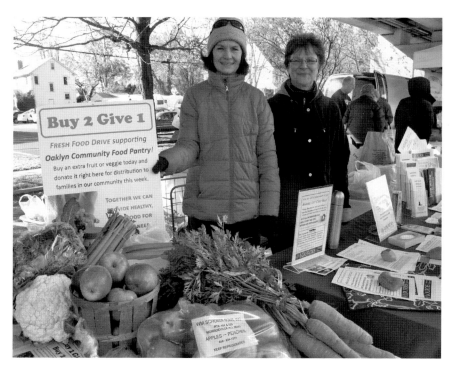

Farmers' markets often sponsor food drives to collect fresh produce and dry goods to donate to food pantries.

Look for the Jersey Fresh label when shopping for produce.

a farmer with me. "We are at a time where people have come to realize they want to know where their food is coming from. They want to talk to somebody and not just go to a store and purchase a food product that is grown by a nameless, faceless person," he said. "All around the state, people are very pleased and happy to talk to the people that are growing their food. I think that is very positive and beneficial."

From a consumer standpoint, Camille Miller, executive director for the Northeast Organic Farming Association–New Jersey, told me that there are other positives for interacting directly with a farmer. "There is much more variety. You will find things at a farmers' market that you won't find at a supermarket," she said. "I used to purposely pick something I had never heard of once a week, just to try. It broadens your palate. You will find someone with an heirloom or a specialty crop, and the nice thing is they will tell you about it, allow you to taste it or even give you a recipe or two. I never had a turnip before I met Mark from Comeback Farm."

Part I

Know Your Farmer

CHICKADEE CREEK FARM

Thirteen generations is a long time for a family to gather farming wisdom. Jess Niederer absorbed all she could from that well of knowledge and went on to continue her education with a degree in natural resources from Cornell University.

When she begins to talk about the soil health at the Niederers' eighty-acre farm in Pennington, her background is clear. "Your soil is what your soil is. We do a lot of composting. A lot of cover-cropping. Our soil gets better every year in terms of its banked-nutrient availability and the ease of working it," she told me.

Her carrots are unusually sweet. She is not quite sure why but attributes it to the terroir of the soil. The spinach that she harvests deep into the winter is so sweet that she brings it to elementary schools in an attempt to get kids interested in eating vegetables.

Potatoes are one of her favorite crops to grow. "They are a really good starch for us to manage in (plant hardiness) Zone 7. Organically, they are grown the exact same way as they were grown in the '20s and '30s. We use the same cultivating tractor that my grandfather used," she said.

She grows twelve varieties of potatoes a year. Corolla, a German potato that is waxy and moist, has become a standout. "It is almost as if it has been

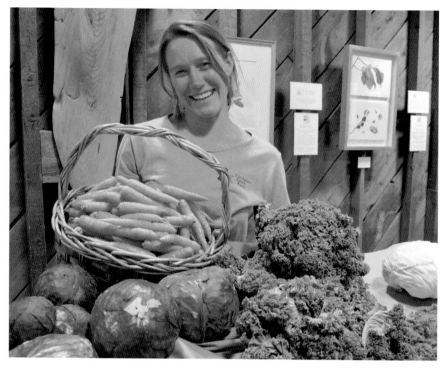

Jess Niederer of Chickadee Creek Farm.

pre-buttered," she said. "It is pale yellow inside. The visual does a lot for the flavor. I love eating them."

Niederer has begun the three-year process of transitioning her land to organic methods. She is currently working seventeen acres, eight of them for vegetables.

Chickadee Creek Farm offers a market-style CSA program that gives a discount to members who buy-in at the beginning of the season. A prepaid debit account allows customers to buy just the vegetables, flowers and herbs they are interested in at the farmers' markets instead of the more traditional CSA model in which members receive a box with predetermined contents. Members may also visit the farm for pick-your-own strawberries, raspberries, flowers, cherry tomatoes and herbs.

Chickadee Creek Farm can be found at the Princeton Farmers' Market on Thursdays, Rutgers Gardens in New Brunswick on Fridays, Stangl Factory Farmers' Market in Flemington on Saturdays and Denville Farmers' Market on Sundays.

Comeback Farm

Clad in pinstriped overalls and a big floppy sunhat, Mark Canright immediately telegraphs that he is a farmer with a dash of old-timey carnival barker inside. He keeps up a steady stream of commentary as customers approach Comeback Farm's market table.

When he was a sophomore in high school, his father, John Canright, a burned-out schoolteacher, started one of the state's first organic farms, Farmer John's Organic Produce in Warren Township, on a seven-acre property.

Canright proudly introduces his daughter, Rebecca, as a third-generation organic farmer. She likes to help out on their thirty-eight-acre Bethlehem Township farm during the summers and at the market on weekends. She is the future farmer at this farm and is very involved in its inner workings.

They recently put in what they hope will be the largest organic orchard in the state. "It is a very exciting experiment. If it proves fruitful in the next few years," she pauses for effect, "I don't know how much vegetable production we'll be able to do." That certainly sounds ambitious. In a few years, they should start harvesting plums, apples, pears, persimmons, blueberries, apricots and nuts.

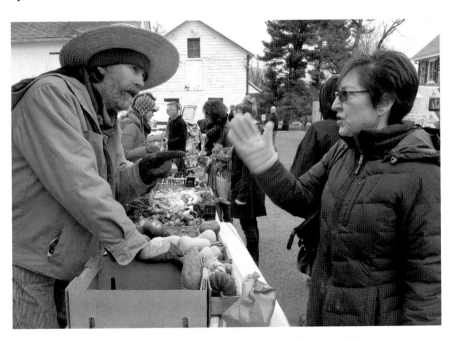

Mark Canright from Comeback Farm discusses how to cook his crops with a customer.

Canright is known for being a four-season farmer. He sees many small farms putting in hoop houses for winter production. He still prefers to keep his crops protected from the elements under fabric in the field. He boasts that he can keep an acre of cold-resistant greens going this way.

The Hunterdon Land Trust Farmers' Market is the only market they do. "I bought the farm in '03 intending to do a CSA and started doing this market. The first day this market started, I was here. It has turned into something that is hard to walk away from," he said while finally getting a lull between customers long enough to hang the farm's vinyl banner from the back of his truck.

"This market has excellent diversity. I feel lucky to be here," he said just before he dashed off to talk up his baby bok choy to the next wave of customers.

Great Road Farm

At the end of the third season at Great Road Farm in Skillman, farm manager Steve Tomlinson sounds confident and content. He's doubled the acreage he's using to produce vegetables and is hatching plans for more eggs and an orchard.

Tomlinson attributed his successful transition from a background in graphic design to farming to mentorship from Mike Rassweiler at North Slope Farm in Lambertville. He has begun to field requests of his own from beginning farmers looking for advice on marketing and packaging products. His artistic background is evident in the way his vegetables are stylishly arranged on market tables.

Great Road Farm's main focus is to provide produce to its partner restaurant, Agricola, in Princeton. Tomlinson admitted that although collaborating with chef Josh Thomsen is enjoyable, there was a learning curve. "It is a challenge to match up what we are growing with when he needs it, but each season it gets easier. I understand more about the restaurant, and they understand more about the farm."

There are also the desires of CSA members and farmers' market customers to consider as well. The restaurant wants head lettuce, but Tomlinson found market customers prefer the convenience of bagged mixed greens. It takes farm staff about four hours to cut and clean the lettuces they need for one market trip. Most of the time they sell out well before the end of the day.

Mixed greens grown by Great Road Farm. *Steve Tomlinson.*

Access to a chef is a plus for Tomlinson. He makes sure that he and his staff pass on information about how to cook their produce to their customers. He finds many people are unsure, and he likes to help them.

With the demands from the restaurant ever present, Great Road Farm doesn't do too many markets. It considers West Windsor Community to be its hometown market and enjoys being there.

ROBSON'S FARM

When Rose Robson went off to college at the University of South Carolina, she had no intention to come back to help work on her family's 1,200-acre farm in Wrightstown. In her sophomore year, her father and grandfather both passed away. The family's wholesale operation was too much for her mother and grandmother to handle on their own, so it was sold. Her mom did hold on to one forty-acre parcel, where they used to have a pick-your-own peaches farm.

Like a bee drawn to a peach blossom, Robson returned home after fluttering about for a few years after graduating with a degree in public relations and business. She enrolled in the Young Farmers and Ranchers program with the New Jersey Farm Bureau. She quickly started working on finding her niche. "There are a lot of ways to differentiate yourself at the market. Some people have rock-bottom prices and some just grow the staples. I grow unique, out-of-the-box things along with the staple things that people want. We grow over seventy varieties of tomatoes, a lot of heirloom melons, every color pepper you can imagine, potatoes and lots of squash. We started to put in antique apples and a row of quince trees, too," she said.

Getting into a traditional CSA business was a challenge for her because she is located within two miles of Honeybrook Organic Farm and Fernbrook Farms, both of which have large, well-established CSA programs. She instead started a buying club that combines her need to be mobile enough to reach new customers with cutting-edge e-commerce. She offers delivery to homes, businesses and Crossfit gyms in the Mount Laurel, Medford, Cherry Hill and Pennsauken area. Customers can also preorder and pick up boxes at the farm on Sundays or at any of her tailgate markets. The concept has taken off, with membership doubling after the first season.

Keeping the peach orchard has been a blessing. Having a desirable crop such as peaches got her into farmers' markets that she wouldn't have gained entry into otherwise. She goes to the Burlington County, Point Pleasant Beach, Princeton Forrestal Village and Westmont Farmers' Markets.

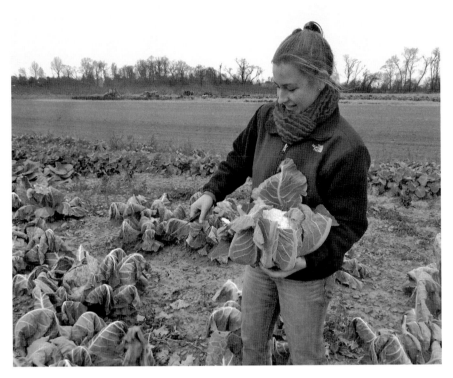

Farmer Rose Robson harvests cauliflower. *Rose Robson.*

Customers who are avid readers of her blog often approach her at the market to chat about a recipe or anecdote about farm life that she shared on the website. "I think that is fun. The farmers' market is a fast interaction. They might not get all their questions answered, or they might want to know more about something," she said. "One person texts me links to any articles about farming. It makes me happy that they think of me."

Part II
A Sampling of Farmers' Markets

COLLINGSWOOD FARMERS' MARKET

Founded in 2000

Q&A WITH DAVID HODGES, MARKET MANAGER

Q: What is your market's mission?
A: The key to our mission is to promote New Jersey agriculture, provide a community amenity and enhance opportunities for local food producers who aren't growers but do value added products with our agricultural ingredients.

Q: How does a farmers' market support the farmers?
A: One of the farms here was months away from selling to developers because they couldn't make a living selling apples and peaches wholesale. They have a magnificent orchard that would have become housing. It was this market that turned [the business] around from an entirely wholesale vendor to a retail vendor. [The farm] now does a substantial amount of business with customers that directly consume the product. It saved the farm, and it is not the only farm that markets like this have saved. It is a fantastic feeling. We actually have farms in New Jersey that wouldn't have been handed down to the next generation without the availability of farmers' markets as a chance to sell at retail.

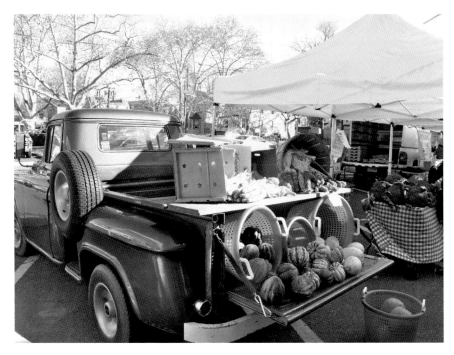

The tailgate of a vintage truck overflows with produce at the Collingswood Farmers' Market.

Q: What are some unique features of the Collingswood Farmers' Market?
A: Our Veggie Valet. It is a free service like a coat check for your produce. You can drop off your vegetables, take a card, pull up your car, show your card, pack up and drive off. For big bags of produce, pumpkins and watermelons, it is pretty popular.

We also have a tablecloth system that is a visual code. Tables with white and green cloths have Jersey Fresh produce that is grown in New Jersey. Red and white tablecloths are for products people may need like lemongrass or Vidalia onions but were not grown in New Jersey.

Q: Why does this market work?
A: It has an amazing, loyal customer base that comes out, in substantial numbers, and buys every week, even when it gets down to thirty degrees outside.

Hunterdon Land Trust Farmers' Market

Founded in 2007

Q&A with Catherine Suttle, director of Cultural Resources and farmers' market manager

Q: How did this market get started?
A: We are a nonprofit. Our mission is to preserve farmland and open space. We felt like it wasn't enough to preserve farmland. We needed to do more to keep farming as a viable livelihood in Hunterdon County. We needed to have this market to give farmers the ability to sell direct to consumers.

Q: Why this location?
A: The land trust has owned the forty-acre historic Dvoor dairy farm since 1999. It is a landmark in this area. It is the only market that I know of that is on grass.

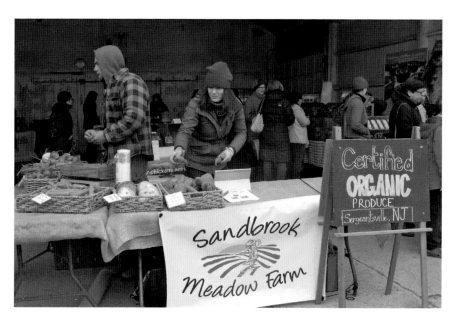

Sandbrook Meadow Farm from Seargeantsville at the winter Hunterdon Land Trust Farmers' Market.

Q: How has the farmers' market scene changed since you began?
A: When we started in 2007, West Windsor Community Farmers' Market and a small market in Sergeantsville were the only ones in existence nearby. Now there are so many more markets. It has affected us because people have more options, but we've managed to maintain and keep customers coming back. We are in the fourth year of a monthly winter market. We started it at the request of the farmers. It's good; it keeps customers engaged over the winter.

Q: Can you quantify how a farmers' market helps a surrounding community?
A: We do a survey every year that calculates the economic benefit for the market on the community. It goes up a little every year. Last year, it was a $2.7 million contribution to the local economy. We measure sales at the market and what people plan to spend in the other businesses in the area.

NEWARK FARMERS' MARKETS

Founded in 2004

Q&A WITH ELIZABETH REYNOSO, FOOD POLICY DIRECTOR FOR THE CITY OF NEWARK, NEW JERSEY

Q: Who shops the markets?
A: With a USDA grant, we were able to survey all of the Newark markets. More than half of the customers were residents. A lot are seniors, mothers or underemployed folks available during market hours who know they can get fresh stuff at the market that is cheaper than the supermarket.

Q: Do the markets provide healthy food access?
A: Imagine it is the first opportunity for some people to taste a Jersey fresh apple or berry. They haven't tasted anything like that. That is something that is hard to find in Newark.

Q: Do the markets include produce from urban farms?
A: We support the urban agriculture happening right here in Newark. Project U.S.E. are kids that grow in their garden, bike to the markets

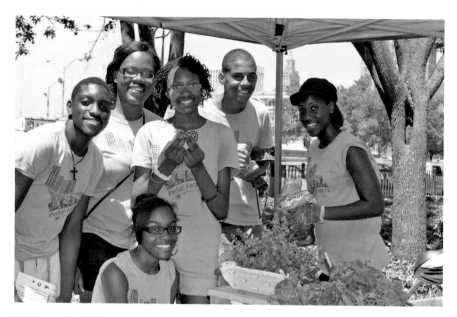

Project U.S.E. Pedal Farmers at the Newark Downtown District Farmers' Market. *Elizabeth Reynoso.*

and do their own marketing. Greater Newark Conservancy runs year-round at 1-acre and 2.5-acre farm sites. Those kids are farming and learning how to run a business. They know their demographics. They were growing collards as early as they could. Other farmers only sell them right before Thanksgiving. People would make a beeline for them, and they would sell out.

Q: How important are SNAP benefits?
A: There are about sixty-nine thousand people in the city with SNAP [Supplemental Nutrition Assistance Program] benefits, and they are spending upwards of $9 million in supermarkets in the area. All of the Newark farmers' markets accept SNAP now. RH Farms from Hackettstown was a new farm with us last season. They said business was steady, and about half of it was in redemptions. Knowing there is a demand, they will be back next year.

Ramsey Farmers' Market

Founded in 2010

Q&A with Nancy Boone, Ramsey Farmers' Market founder and manager

Q: Tell me about Ramsey.
A: Ramsey was once a farming community. The soil was very boggy. At one point, we were the strawberry capital of the Northeast. Most of the farms were small. We don't have any farms left here now.

Q: What prompted you to start a market?
A: I've lived in this area my whole life, and I always had an interest in bringing something to the community that I thought was worthwhile. Our market is a nonprofit sponsored by the Ramsey Historical Association. As a nonprofit, we've been able to pay it forward. Quite often, we collect produce from the farmers and nonperishables from visitors, and we deliver to the food bank in Mahwah on Monday. Our proceeds go back into the community at organizations such as the Center for Food Action and Meals on Wheels.

Q: Where is the market located?
A: We are located at the historic train station. The train made Ramsey a focal point in the area for local farmers. Farmers would ship their wares from the station.

Q: Tell me about your vendors.
A: We started with twelve vendors, and now we have between forty and forty-five. I didn't just make it Jersey-centric. I think the line of demarcation is just that: an invisible line between the states of New York and New Jersey. We have farms and purveyors from both states. Each of these businesses that come to the market are either a family-run farm or a small business. Often the entire family comes to help.

Q: What are some highlights of the Ramsey Farmers' Market?
A: We have chef demos every week. They come, shop the market and cook. It's very serendipitous. Josh Bernstein, executive chef at Spuntino's in Clifton, comes every other week. People will see a product and have no idea what to do with it. He'll come up with a new way to cook it.

The arrival of strawberries in spring is highly anticipated in New Jersey.

Q: Why should people shop at a farmers' market?
A: You will get fresh, you will get local and you'll be able to establish a rapport with the people who are actually growing your food. There is value added. You know your food source.

Q: How do you get the word out about the market?
A: I write a short little letter every week that I send to thirty-two local papers. Every Friday morning, we send out highlights of specials for the week to

spark people to come back. People can find us on our website, Facebook, Pinterest and Instagram.

Q: Why take a break between your outdoor and indoor markets?
A: I want people to be looking forward to the reopening in June when we kick off with the Strawberry Festival and know the Ramsey Farmers' Market is back.

West Windsor Community Farmers' Market

Founded in 2004

Q&A with Chris Cirkus, market manager

Q: How does West Windsor keep up with changes on the market scene?
A: West Windsor and the surrounding area's demographics have changed in the last ten years. It has changed what is being grown for the market. Things that are not mainstream sell more—like tat soi. Chia-Sin Farm does really well at our market. We have a lot of Chinese and Indian families shopping the market. Great Road Farm started growing ginger and some really cool little eggplants.

Q: What are the logistics like being located in a train station parking lot?
A: The market doesn't magically appear. Everything has to come out of the sheds and get set up. That is separate from what the farms are doing. Rain or shine, hot or cold, it doesn't matter—I get there at 7:00 a.m. every Saturday morning and set up with the help of volunteers from 7:00 to 9:00 a.m. The market is over at 1:00 p.m., and we are done by 2:00 p.m. It is quicker to put it all away than set it up. In the four years I've been manager, it has never been the same farmers' market twice. The vibe is always the same, but there is always something logistical that changes the dynamic for the day.

Q: How can a farmers' market be a resource for families?
A: What a great place to expose your children to real food. I have a preschool background, and I taught cooking classes to kids. For me, the farmers' market is a direct extension from that. Kids have no concept of what food is. They don't

West Windsor Community Farmers' Market manager Chris Cirkus braves all kinds of weather. *Chris Cirkus.*

know you can make tomato sauce from tomatoes. The farmers' market is such an untapped education tool for families. That is part of why I love it.

Q: How important is it for the vendors to support one another?

A: Brands such as Jams by Kim and Frank's Pickled Peppers are buying locally from farms and bottling locally. We encourage that. We want the commerce to stay in the community.

Q: How important is it to have regular customers?

A: I'm always astounded at the strong regular base. We really see it at the beginning and the end of the season. Those tried-and-true people know they are making a difference to these farmers. They really come out. People don't want to come out and walk around in the rain, but the regulars come. It is so heartwarming to see that.

Part III

Spring

ASPARAGUS

My first job after graduating culinary school was at Brandl., a small fine-dining restaurant in Belmar. I peeled a vast quantity of asparagus there that spring, and I loved every minute of it. Yes, the task takes a few moments, and you will question whether it is worth the time. It is. Each bite is tender. If you don't peel it, the butt end can be stringy.

For this job, I swear by a Kuhn Rikon carbon steel Y peeler. Mine got me through that season's pile of asparagus and has kept going for the years since. Line up a handful of spears to be even at the tip end. Trim the bottoms to equal lengths. Peel until you hit moist flesh, slanting upward about one-third of the length of the spear. If you go a bit crazy with the peeling, no worries; make a shaved salad.

The majority of asparagus I prepared at Brandl. was bound for one of its specialties: a creamy risotto enriched with Parmesan and cream. After blanching and shocking, the spears were cut into half-inch pieces and stirred into the rice. The tips were reserved for garnish along with huge lumps of lobster meat poached in vanilla bean–laced butter. Scrumptious!

Lambertville cookbook authors Christopher Hirsheimer and Melissa Hamilton photograph their daily lunches in their Canal House cooking studio and blog swoon-worthy images and descriptions. Their daily posts in spring

may include a creamy pasta and asparagus dish they dubbed "spring's stand-in for summer's potato salad," a composed salad of fat spears with mortadella, boiled egg, lemon and potatoes and a broth swimming with bits of ham, tiny pasta and asparagus. All of these are examples of how to cleverly use the little bits left in the fridge to make a quick and satisfying meal.

Eggs just seem to go with asparagus. Both are symbolic of spring's fertile beginnings. For a one-pot meal, try roasting asparagus in the oven and then cracking a few eggs in the pan. Continue to bake until the eggs are set. Scatter with a handful of good cheese.

If you feel a little gutsier than normal, go for an asparagus soufflé. You'll feel so proud when you pull the puffy golden dome out of the oven. Just don't jump up and down to celebrate or that baby will fall.

Hollandaise sauce is the classic combo with asparagus. Slip a bunch of asparagus into salted boiling water and cook just until the spears begin to bend and are crisp-tender. Use Julia Child's well-loved hollandaise recipe. Be sure to add melted butter to the whipped eggs drop by drop until you work up to a tiny continuous stream of hot butter. Child liked to use her fingers to dip the spears into the sauce and gobble them up. You will, too.

New Jersey is the fourth-largest asparagus producer in the country. Cultivars with names such as Jersey Giant, Jersey Knight and Jersey Supreme were developed at Rutgers University. It makes sense that we have a certain amount of pride that swells when choosing a bunch at the farmers' market. We also have a sense of impatience as we wait for their arrival. Spring has officially sprung when they show up.

When purchasing asparagus, look for straight and sturdy, medium to fat spears with tightly closed tips. To store, slice a sliver off the ends and stand the bunch in a half-inch of water. Refrigerate until ready to use. Rinse in cool water. Sand may cling to the tips.

BEETS

Beets can be almost cloyingly sticky sweet. In the savory kitchen, we look to balance that sweetness with acid. As a kid, I actually looked forward to visiting restaurant salad bars for the chance to eat tangy pickled beets. Today, I'll toss a few tablespoons of Dijon mustard with some roasted and peeled beets and spoon the magenta combination over Boston lettuce leaves. Sometimes all you really need is three ingredients.

When I was the chef at A Better World Café in Highland Park, one of our top-selling sandwiches was a goat cheese and beet panini sandwich. Even kids liked it!

The Culinary Institute of America adds horseradish's heat to temper the sweet in Norwegian beet- and horseradish-cured salmon. After curing for three days, the *gravlax* will have a vibrant, rosy hue thanks to the beets. It looks stunning on a bed of dill fronds.

Bunches of beets from Great Road Farm. *Steve Tomlinson.*

Don't discard the leaves and stems. Cook smart and make two meals for the price of one. While you've got the beetroots roasting in the oven, spaghetti with beet greens can be cooking on the stovetop.

Raw beets sliced very thinly are wonderful in salads. Seek out gold, white and candy cane–striped Chioggia beets for a colorful mix. Shred some for slaw or try out one of my favorite new kitchen tools, the spiralizer, to form beet noodles. I especially enjoy beets with saltier cheeses such as feta and ricotta salata, as well as the addition of fennel, citrus and red onions.

For those who love fermented foods, try making beet kvass. I had this tonic for the first time at a class taught by Angela Davis, a holistic health coach from Jersey City. Her enthusiasm for kvass won me over. Simply made of diced fresh beets, sea salt and spring water, the mixture ferments for a few days and ends up being a really energizing way to start your day. If you'd rather a drink that is sweeter yet still good for you, slip a roasted beet or two into your next strawberry and banana smoothie.

Betanin, the red pigment in beets, is the perfect substitute for artificial red food coloring in baked goods. Popular blogger and cookbook author Joy the Baker tops a dark chocolate cake with magenta beet and cream cheese frosting. Speckles of what she calls "nature's sprinkles"—or shreds of roasted beets—run through the creamy topping. Pureed beets are showing up in many dessert options these days such as dark chocolate cupcakes and raw vegan treats.

Bok Choy

Bok choy loves cool weather. Spring's volatile temperature dips don't bother them at all. By mid-April, the bulbs of baby bok choy have fattened up and are ready for market. Crisp, juicy stalks beg to be bitten. The dark-green leaves crave a quick sauté.

Although this vegetable may have left you wondering in the past what to do with it, you will quickly find it is perfect for fast weeknight suppers. Baking guru Dorie Greenspan uses the oven a lot. This gave her the genius idea of using a classic French technique (*en papillote*) to gently steam bok choy in the oven. She combines spring ingredients—sugar snap peas, baby onions and garlic—along with the bok choy in an aluminum foil or parchment paper packet. Use the same technique for individual servings with the addition of salmon filets for a fast and fab meal.

Bok choy.

My friend Norna Fairbanks, a well-seasoned chef, grumbled to me when I started to get excited about this technique. "That is so '80s," she told me dismissively. "But I am too young to remember that," I retorted with a whine. People love to unwrap their own personal entrée. The moment fragrant steam escapes and you get a much-anticipated glimpse inside is magical. Cleanup is as simple as crumpling up some paper. This classic method was included in iconic French chef G.A. Escoffier's repertoire, and I feel honored to carry on the flame.

A Sunday supper of braised duck legs with mustard greens and bok choy also turns to the oven for mostly hands-off cooking time. The bok choy will be meltingly tender and infused with the delicious juices released by the duck. If duck is not in the budget, substitute dark chicken quarters.

The website The Kitchn always has inventive recipe ideas for packing your lunch. Its recipe for soba noodle salad with wilted bok choy will turn Sunday's dinner into a marvelous Monday lunch that is great served hot or cold.

Bok choy's mild flavor pairs well with more assertive ones. Chili oil or flakes, toasted sesame seeds, black bean paste and pungent garlic adore it.

Asian staples such as fish sauce, wasabi and citrusy ponzu also are good bets. David Martone, chef and owner of Classic Thyme Cooking School, teaches a class with lobster medallions over ponzu-flavored wilted baby bok choy with a spicy aioli. Date night, anyone?

Tender seared scallops glazed with hoisin sauce benefit from being served on a bed of crunchy bok choy, carrot and apple slaw. Once you taste fragrant lemongrass and thinly sliced beef stir-fried with bok choy, you will be eager to come home to cook dinner instead of ordering in the same boring Chinese takeout.

Broccoli Rabe

Broccoli rabe is perfect for a spring fling. Let's face it, adding the alluring Italian accent is way more fun than plain ol' broccoli tonight. Both have similar cooking methods, but rapini has that "been around the world" vibe. It's a little skinnier, more flavorful and able to tempt you out of your comfort zone for a little adventure.

Blanching for a minute or so in boiling water and shocking afterward in an ice bath is the best thing you can do when prepping broccoli rabe. The florets will stay green and tender-crisp in any recipe you choose. You can't go wrong with a quick sauté with raisins and pine nuts or by adding a generous helping of minced garlic, red pepper flakes and a squeeze of lemon juice.

Start out your day with an omelet oozing with fontina cheese and broccoli rabe. Or invite your friends over for a game of bocce ball and slow-roasted pork, broccoli rabe and provolone sandwiches served family-style. Make the pork in the morning. The house will smell amazing when the guests arrive, and all you'll have to do is lay out some crusty Italian rolls and open a bottle of Lambrusco, a sparkling red wine. If your friends like to get together for a hands-on cooking party, try making cheese and broccoli rabe sausage together from scratch.

A simple bowl of pasta, sausage and broccoli rabe is one of the best dinners ever. Especially made with a fresh pasta such as the rigatoni or fettuccine from Nicola's Pasta Fresca. He sells them at the Sparta winter markets and the Summit and Westfield Farmers' Markets.

Think about using broccoli rabe with full-flavored meats such as short ribs or duck breasts. Pan-seared swordfish and branzino are also excellent partners. This is the kind of dish that chef Claudette Herring at Via 45 in

Red Bank may come up with when she pulls together her daily menu after visiting the market.

For vegetarian options, use it as a pizza topping either sautéed or in a broccoli rabe pesto. Jersey City Veggie Burgers sells a white bean broccoli rabe burger at Rutgers Gardens Farmers' Market in New Brunswick and several of the Jersey City markets. Stop by for a taste or attempt to create your own version at home.

Whatever broccoli rabe recipe you choose, mangiare bene. Eat well.

COLLARD GREENS

My father was raised in the South. Somehow, along with his blue eyes and fair skin, my DNA is preset with a love of collard greens, grits and all the pleasures southern food offers. Although my step-grandparents, the Raulersons, take great delight in introducing me as their "Yankee granddaughter" whenever I visit them in Jacksonville, Florida, my inner southern gal feels right at home.

I look forward to reading local produce distributor Zone 7's weekly e-mails on what is newly available from area farms. My heart always skips a beat when I see that Garden State Urban Farms in Orange has begun to offer collards grown in its greenhouse. I am so ready to cook up a mess of greens.

At Elijah's Promise in New Brunswick, chef Carol Eggleston loves when the catering department gets a huge delivery of collards in from a farm. She'll start by removing the tough center rib. The leaves are stacked and rolled like a cigar and cut into one-inch ribbons. Then they are given a bath in a sink of cool water and dried thoroughly. At this point, she sometimes bags them up and puts them in the walk-in freezer for future use.

When she cooks them, she prefers to let them take their time to cook slowly. Typically, a cured pork product such as a ham hock is added to the pot. Smoked turkey is Eggleston's favorite way to give the greens lots of flavor. Wings, necks or drumsticks can be used. Chef Eggleston usually makes a batch to serve two hundred. I probably ate ten servings whenever I heard her siren's call from the kitchen when I was working in the building.

Vegetarians need not fret. Southern food guru Virginia Willis uses smoked salt in her recipe for collard greens, which delivers all the smoky flavor without the meat. I also like to use smoked paprika for a switcheroo when catering to vegetarians.

Bryant Terry was inspired to write his book *Vegan Soul Kitchen* after developing his citrus collards with raisins redux. His book does a great job lightening up southern recipes. I love the unexpected sweetness that the orange juice and raisins bring to this dish.

Often these greens are cooked down to almost mush. Freshen up the flavors and cooking time with collards and toasted coconut. Wilt them briefly in coconut oil for a more toothsome option that is on the table in a half hour. Garnish with toasted coconut and almonds.

At Seed to Sprout, a vegan eatery and juice bar in Avon By the Sea, it takes advantage of collards' sturdy leaves in one of its most popular menu items: the cashew collard wrap. Carrots, sprouts and a rich cashew cream with a consistency similar to hummus are rolled up in a collard leaf. You can't get much fresher than that.

DANDELIONS

Lovers of lush lawns start losing their composure as dandelions begin to pop up and dot the landscape. Instead of pulling your hair out, you could pull those dandelions up and eat them. That's right, dandelions are completely edible.

Leaves are tastiest when young, before the plant flowers. They are rich in iron, beta carotene and calcium. A bit bitter, these greens are perfect to cut through rich partners such as cheeses, eggs or meats. Eat them raw in a salad or sautéed as you would any other green such as Swiss chard or spinach. A quick blanch in salted water will help remove bitterness.

If you've had a pasta maker sitting on a shelf untouched since you were married in 1982, dust it off to make dandelion green ravioli. Or if making pasta from scratch seems daunting, use wonton wrappers instead to swaddle the rich, creamy, green-studded filling.

You would think farmers would avoid a plant that is considered a weed, but Petrolongo Farm in Hammonton actually specializes in growing dandelions. The bitter greens can be used in a multitude of ways. Their flowers are harvested for dandelion wine made by Bellview Winery in Landisville. The Quarella family has owned the winery for one hundred years. Blossoms must be harvested in the morning and processed the same day. More than that, I can't say. The Quarellas fiercely guard their secret recipe handed down from their Italian ancestors. On the winery's blog, Nancy Quarella describes their wine's flavor notes as "a hint of lemon and something herbal, kind of piney

or slightly minty—almost like eucalyptus." The wine ages well. Her family kept a bottle for fifty years and loved how it turned amber in color and more complex in flavor like a sherry.

The Scandinavians turn the blossoms into a delicate jelly that has a flavor like honey. Skip the canning process and make a jar of jiggling jelly that can be kept in the refrigerator. Use it with toasted artisan bread.

Korean cuisine also has many uses for these edible greens. Dandelion *kimchi* is one to try for those who love spicy condiments. Mindeulle Muchim is a salad of blanched greens mixed with sweet rice syrup, fiery red pepper paste, sesame oil, soybean paste and vinegar.

Fava Beans

I grew fava in my small raised garden bed one year. The yield for the entire season was unfortunately only enough to make one spectacular pasta dish featuring them. Now I let the farmers grow them for me and buy one pound per person when planning my recipes.

Fava beans are a bit finicky to prepare but well worth the effort. Each pod holds three to eight plump, buttery beans inside its downy interior. After removing from the pod, it is best to blanch favas in salted boiling water for thirty to sixty seconds to soften them. Shock the beans in ice water to stop the cooking process. Pat them dry and pop the bright green beans out of their milky skins.

If that seems too fussy, lightly oil and salt the whole pods and cook them on the grill or under the broiler. The exterior will blister while the beans inside steam. After the pods cool slightly, dig in. Have plenty of napkins on hand as you extract the beans right at the table.

A smaller, concave pasta such as *campanelle* or *orechiette* lets the favas nestle together perfectly with other ingredients such as bacon and ricotta. Be on the lookout for Fulper Family Farmstead of Lambertville at one of the ten farmers' markets it staffs for its creamy, fresh ricotta made by fifth-generation dairy farmers. Ravioli stuffed with fava beans, ricotta, mint and a brown butter sauce are transcendent. Pick up fresh sheets of pasta at the market if you don't have time to make your own.

Emiko Davies, who writes about regional Italian food, likes to serve a first course of fava bean crostini. The beans are smashed in a mortar and pestle and seasoned with pecorino Romano and lemon before being slathered on

grilled ciabatta bread. Pick up a loaf of bread and some cheese from the vendors at your local farmers' market for your own regional meal.

Artichokes stuffed with fava beans, fresh mint and dill are eaten throughout the Mediterranean. In Egypt, *ful medames*, a stew made with dried fava beans, is eaten for breakfast. Give it a try at Zaitooni Deli in Red Bank. Falafel made with favas instead of chickpeas is another great way to use fresh or dried beans. Adding lots of fresh herbs to the mix makes the inside of the patty bright green.

Fava beans contain tyramine, which should be avoided by anyone taking antidepressant drugs that are monoamine oxidase inhibitors (MAOIs).

Lettuce

One of my favorite ways to eat lettuce is in bulgogi, a Korean dish that features tender, thinly sliced beef marinated in soy, sesame, garlic and sugar before being quickly cooked on an electric frying pan or grilled. Bring a bowl of chilled red or green romaine lettuce to the table. Choose a leaf, top with a little rice, a few slices of the tender, juicy meat and some spicy chili garlic sauce. Take a perfect bite of the cool crunch of lettuce, the succulent beef and soft rice. Even better, the stove doesn't need to be turned on if you use a rice cooker.

In bulgogi, the lettuce is a supporting actor. Don't be afraid to let lettuce be the star. When I worked at Brandl. in Belmar, I learned that lettuce can be grilled. The chef takes a heart of romaine, sets the inner portion down on a blazing grill and chars it. Romaine has enough heft to handle the heat. Set the grilled lettuce on a platter, slather with freshly made Caesar dressing and shavings of a good hard cheese. Switch things up with Bibb or Boston lettuce, some chards of aged gouda, pickled red onion and your choice of creamy dressing.

Lettuce is a staple crop for Flaim Farms in Vineland. Its operation is predominately wholesale. Several schools serve its produce in lunches. The only farmers' market it sells at is the Collingswood Farmers' Market. Visit the farm for a serious spread of produce, including romaine and leaf lettuces. If Kevin Flaim is available, chat him up about his family's farm, which has been operating since 1934.

Heirloom varieties that are much more flavorful and delicate do not ship well, so they never make it to most restaurants. Their green, red and

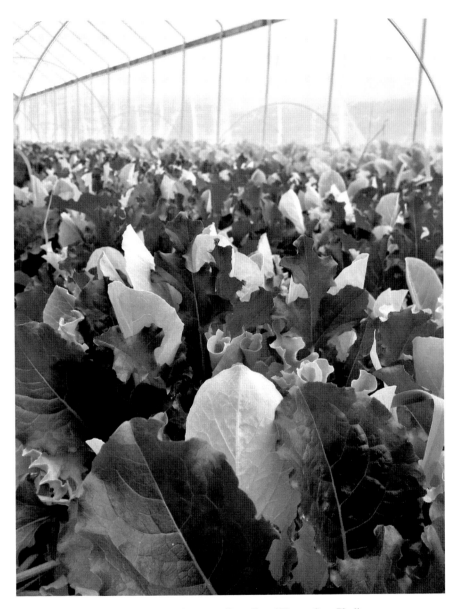

Red and green lettuces in the greenhouse at Great Road Farm. *Steve Tomlinson.*

speckled hues appeal to the eye. The difference in the shapes of their leaves and their textures inspire different uses. At the farmers' market, look for mixed greens picked early in the morning, and prepare to have your opinion on lettuce change.

Just by experimenting with how you cut your lettuce can make a ho-hum salad new again. Lay long leaves on top of one another, roll and slice into ribbons. Cut some into one-inch squares. Use your hands to roughly tear the leaves. Small leaves can be left whole. Jumbling together a few types of differently prepped lettuces creates nice textural contrast.

To ensure that your dressing doesn't steal the spotlight, use a more demure vinegar such as rice wine, Champagne or white balsamic. Flavored vinegars make things interesting. I break out little bottles of peach, apricot and coconut vinegars. They pair well with the addition of fruits and berries. Choose a neutral-flavored oil such as safflower or grape seed instead of olive oil. Hazelnut, walnut, almond and avocado oils bring a new flavor to your plate.

A good salad needs some crunch. Don't forget to add a handful of toasted nuts, sunflower seeds, good croutons, chopped apples or crisp bacon. If you can't face another salad, make soup. Quickly sauté a roughly chopped head of lettuce in some butter, add some broth, a chopped tomato and some fresh herbs.

Before preparing any lettuce recipe, make sure it is impeccably clean. Float the leaves in a bowl of cold water. Use a salad spinner or pat dry with a clean dishtowel just before using. If your lettuce looks a bit wilted after the trip home in a hot car, perk it up with a quick dunk in an ice bath.

MINT

Mint would take over the world if left to its own devices, which is perhaps why its cooling presence is known in much of the world's cuisine. Do your part to curb its rampant sprawl by adding its peppy flavor to meals. Alstede Farms in Chester almost always has bundles of the fragrant herb at the dozen markets it sells at throughout the season.

Don't let the specter of jiggly fluorescent green mint jelly muddle your mind about how to use mint's flavor to your advantage. Mojitos are the perfect go-to drink for happy hour. Bartenders don't like to slow down and muddle the leaves during a rush, but a few grinds of the wrist won't be bad for your business. Support local businesses such as Jersey Artisan Distilling, the first distillery in New Jersey since Prohibition, by using its Busted Barrel silver rum in your mojitos.

Or you could combine the mint, rum and lime in a mojito-inspired marinade for grilled chicken. Brush the marinade on skewers of shrimp fifteen to twenty minutes before firing up the barbecue.

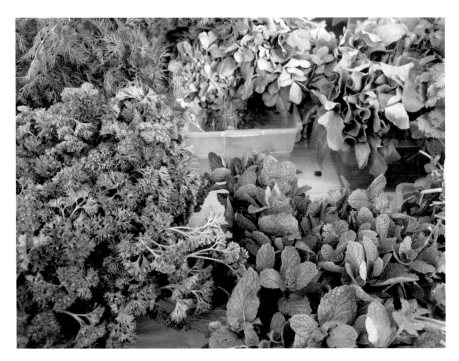

Curly parsley on the left and mint on the right.

Loads of fresh mint and cumin seeds add herbaceous and earthy flavors to Middle Eastern–style lamb or beef meatballs. Serve them with tomato sauce or yogurt strewn with yet more chopped mint as an entrée or substantial sandwich. Wash them down with fresh-squeezed lemonade loaded with the herb, like it is served at Mamoun's Falafel Restaurant. I can't resist dropping in for one when I'm near its stores in Hoboken, New Brunswick and Princeton.

Peas are readily available now and the perfect partner for mint. Give yourself twenty minutes to clear your mind while stirring up a pea and mint risotto for dinner. Pea and mint soup topped with garlic croutons is equally satisfying served hot or chilled.

Vietnamese summer rolls are translucent, allowing you to see the pink shrimp, ribbons of green mint and shreds of orange carrot just below the surface of the pliable wrapper. They are lots of fun to make with kids. Just have all the ingredients ready and help them get the hang of rolling.

Mint chutney is one of my favorite parts of eating at an Indian restaurant. It's actually quite easy to blend up a batch with cilantro and chiles to slather on naan or samosas at home. I like to make the chutney and freeze it in ice

cube trays. In winter, when I'm craving something green and spicy, I simply defrost and dip into the taste of spring.

A bunch of mint will keep for a week when arranged like a bouquet in a jar with a few inches of water at the bottom. If you find you have more than you can use, allow the bunch to air dry and use in a tea.

PARSLEY

I baby a pot of parsley on my kitchen windowsill all winter. Jersey growers that use a greenhouse have been doing the same thing but at a much grander scale. Look for vibrant bunches of flat leaf or curly parsley at market. You often see parsley used as a garnish and overlook it completely as an ingredient. What a waste. Let its cheery green hue come to the center of the plate. All of these parsley-powered recipes are fast, so you can spend more time outside soaking up the sun's rays.

As soon as the daytime temperatures start to hover around fifty degrees, we haul our gas grill out of the garage. A nice juicy grilled steak with *chimichurri* sauce will make you feel like you took a weekend holiday to Argentina (after-dinner tango dancing optional). Garlic, red wine vinegar, oregano, olive oil and pepper flakes combine with chopped parsley to make a condiment that should become a go-to combo during grilling season. Use it within a week; pop any extra into the freezer.

The French favor *persillade*, a mixture of parsley and garlic. Chef Thomas Keller has a recipe for cod persillade that is revered in the blogosphere. With a handful of ingredients you already have on hand, Keller shows that French food does not have to be complicated and can be fast, too. Simply dip a fish filet in mustard, then breadcrumbs mixed with persillade and bake. Jacques Pepin offers a convenient option to use persillade with a store-bought roasted chicken in a composed salad. His recipe utilizes all the yummy juices from the chicken and about ten minutes to make a chic supper.

Tabbouleh salad screams summer to me. I know it is a bit early, but you can almost taste sunbeams in this Lebanese salad combining loads of chopped parsley with tomatoes, bulgur wheat, mint and lemon. It is worth tracking down vine-ripened tomatoes from the greenhouses at Sun Haven Farm in Hillsborough.

After moving my muscles doing spring cleanup chores in the garden, an easy one-pot meal of mussels with white wine, a splash of cream and a generous handful of parsley is perfect.

Peas

"Eat your peas!" is the stern command uttered by mothers everywhere. I never need coaxing to eat them—although trying to balance them on my butter knife before putting them in my mouth did considerably slow down dinnertime. I like to queue up one of my favorite songs, "Pass the Peas," written by James Brown, the Godfather of Soul, to get in my cooking groove. Try one of these ideas for English, sugar snap or snow peas to round out your dinner plans.

Snow peas have a string that needs to be removed. Grasp at the stem end and pull the string along the straighter edge of the pea. I love to eat them raw, tossed with segments of orange, a drizzle of toasted sesame oil and garnished with black-and-white sesame seeds. It's a striking side dish with soy-glazed fish.

Sugar snap peas rarely make it to the fridge. I usually eat them right from the bag after buying them. If you have more self-control than I do, toss them with julienned carrots and soba noodles and add them to a stir-fry.

Remove English peas from their pod. Find a friend to help—or an unsuspecting husband like mine, who stopped into my kitchen at work one night to say hello and got stuck shelling a case of peas before we could go out for the evening.

An easy rice pilaf starts out with a bit of sautéed onion in olive oil. Add one cup of rice to the pan and stir to coat with oil. Cover with two cups of chicken broth and bring to a boil. Swirl in two cups of shelled peas and simmer covered for twenty minutes.

Lovely little peas are my favorite part of a pot pie. Be generous with the green gems, fresh herbs and other veggies you pair with chunks of chicken in a creamy sauce. Choose a traditional version with a top and bottom pie crust or spoon the filling into a ramekin and top with puff pastry or a biscuit. Bake until golden and bubbly. If you happen upon one of the delectable pot pies made by Princeton's Griggstown Farm and pass it off as your own, nobody will be the wiser. Look for them at the Bernardsville, Denville, Montgomery and West Windsor Community Farmers' Markets. Griggstown's sausages would also serve as a centerpiece for a casual English supper with pea puree, mashed potatoes and onion gravy.

For an Indian twist, make *matar paneer*. A rich tomato gravy seasoned with turmeric, ginger, ground coriander and *garam masala* is the lush base for sweet peas and chunks of paneer, a firm cheese used in Indian cuisine. I've used cubes of extra firm tofu instead of the cheese for vegan guests.

Sugar snap peas.

Sweet peas pair nicely with a salty element in a dish. Pancetta and peas in a Parmesan cream sauce over fettuccine is a winner for a weeknight dinner. Mint, melted butter and crème fraiche all happily assist in jazzing up the basics.

A quick blanch in salted boiling water and a dunk in an ice bath make peas ready to cook in almost any meal or to bag up for the freezer. Instead of discarding the pods, simmer them in some water. Use the broth as a base for vegetable soup.

If you are lucky enough to come across tender pea tendrils, grab them. Add a tangle to the top of a tuna sandwich. Anything you do with them will feel special.

Radishes

On Easter Sunday, I am not preoccupied with nibbling the ears off a chocolate rabbit or hunting for eggs. I am thinking of all the ways to enjoy

Easter egg radishes. Pastel-colored cuties, these assorted pink, violet, red and white radishes are almost too pretty to eat. I can't resist bringing home a few bunches to play.

Having radishes in the fridge is usually an excuse for me to make tacos. Their crunch complements just about any meaty filling. I'll also slice some up thinly to make a quick pickle by submerging them in a mixture of rice wine vinegar, sugar and salt. They are a great garnish for a bowl of ramen soup along with a hard-boiled egg and scallions.

Radishes soften and sweeten with roasting. The skin takes on a crinkly quality that makes eating just one or two impossible. These are terrific as is and glorious alongside a leg of spring lamb, which should be available now from a local farm.

For a fast dinner, I'll take a bunch of radishes, cut them in half and bake them in a parcel of parchment with a nice fish filet, some orange slices and a handful of fresh herbs.

The greens are also edible. Roast the radish root and greens on separate baking sheets to use up every bit. While they are in the oven, stir up a pot of creamy polenta. Top with the roasted veggies. If you have extra roasted radishes, add them to a potato salad with mustard seeds. What a perfect

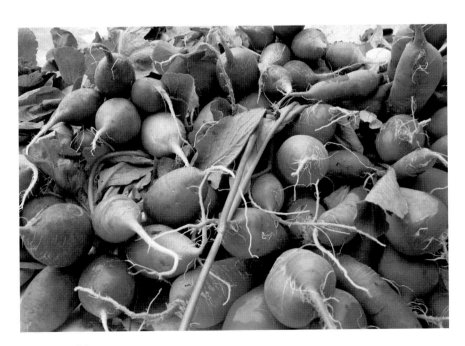

Assorted radishes.

side to go with sandwiches loaded with thick slices of ham left over after Easter dinner.

Pair the peppery bite of radishes with a sweeter element in a salad. Segmented citrus and scallions are a favorite. Slice up the radish tops and toss them in, too. Strawberries, rhubarb and radishes make a lovely salad enlivened with mint and spinach.

The French love radishes on a *tartine*, an open-faced sandwich. Try combinations like ricotta and radish; avocado, asparagus and shaved Asiago cheese; and the ultimate spring simple pleasure, a slice of good bread, whipped butter, Maldon sea salt and radish. They will hold you over until sandwiches loaded with slabs of heirloom tomatoes are an option.

Look for fresh bunches of radishes at market with vibrant greens. Store radishes in the crisper drawer of the refrigerator for three to five days. Thinly sliced radishes can be stored in a bowl of ice water in the fridge for up to one day. They will be nice and crisp when you are ready to use them.

RHUBARB

When I was young, I lived with my grandparents and great-grandmother, Nana. A lover of long car rides, Nana would straighten her cat eye glasses, spritz herself liberally with perfume and pile us into Matilda, her Chevy Nova, for a jaunt. Depending on the time of year, our destinations would vary, but procuring a prized snack was always on the agenda. In the spring, a trip specifically to find rhubarb pie was made.

The tart tang of rhubarb foiled by a slump of sweet strawberries is a favorite flavor combination. Pull out a few recipes now to be ready to spring into action when you find yourself unable to resist coming home from the farmers' market with an armful of rhubarb and a flat of strawberries. (Or does that just happen to me?) That classic strawberry rhubarb pie has thrilled my family for generations. Yours will love it, too.

Fiddling with a top pie crust can admittedly be maddening. Don't skip enjoying homemade pie because of it. Go rustic with a free-form pie dough. For irresistible snacks, strawberry rhubarb empanadas fit into your hand for all that flavor in a less messy vehicle. Pick up a package of dough in the frozen foods section of your supermarket.

Inevitably, I go a little rhubarb crazy and experiment like mad every year with new recipes. If you are lucky enough to have some rose bushes in bloom,

Rhubarb cooking down for a chutney.

rhubarb and rosewater syrup is wonderful as a base for cocktail or seltzer drinks. Drizzle some over your morning yogurt with chopped pistachios for a Persian flair. I like to bottle the pink syrup and give it as gifts.

My favorite experiment has been rhubarb chutney. As a novice at canning, I turned to Food in Jars, a website run by Philadelphia-based canning guru and author Marisa McClellan. Her combination of savory onions, raisins, spices and vinegar with the rhubarb is a genius move. I served the chutney at an international appetizers–themed party with crispy *papadums* from the Indian grocer. The guests went crazy for it. I was so glad I canned some so I could eat it all year long.

Using the same method for making a *tarte tatin*, a rhubarb upside-down cake, results in a caramelized fruit layer glistening atop a homey cake that is started on the stove and then baked in a cast-iron skillet. For a fancier presentation, I like to make roasted rhubarb and custard tarts. I love to see the translucent pink of rhubarb's juices settle on top of the cream. Roasting the rhubarb just until tender helps the stalks maintain their shape and color.

Think of the tart flavor of rhubarb for savory dishes, too. Lemon rhubarb chicken will add some intrigue to midweek chicken dinners along with fresh

ginger and shallots that can also be picked up at the farmers' market. Use the color and crunch of raw rhubarb in a salsa to top fish tacos.

At the market, look for rhubarb stalks that are thick and firm. They resemble celery stalks in shades ranging from shocking scarlet to light green. Bundles are usually sold without leaves. The roots and leaves contain oxalic acid, which can be toxic.

Strawberries

Every spring, I officially come down with a case of strawberry fever. I'll get a doctor's note to prove it. Personally, I abstain from non–New Jersey berries all winter, as I intend to gorge myself on the sweet and slightly tart morsels of joy as soon as they appear during their fleeting season.

My grandfather would always make one much-anticipated batch of strawberry shortcakes. Making them always reminded him of growing up on his family's farm in Upper Saddle River. As we dug into the tender, warm biscuits layered with fresh whipped cream and strawberries tossed in sugar, he would have us in tears laughing at stories of his boyhood antics long in the past.

My absolute favorite ice cream flavor is strawberry. Emma Taylor at Jersey City's Milk Sugar Love Creamery and Bakeshop started her ice cream business with a pushcart at the Van Vorst Park Farmers' Market. She quickly forged a relationship with fellow vendor, farmer Ed Huff from Central Valley Farm in Asbury. "We get organic strawberries from him that are pesticide-free and ruby red when you bite into them," she said. Now patrons of the market can walk across the street to her shop to try Huff's berries in one of her ice cream flavors. Try it in an ice cream sandwich with her big, decadent chocolate chip cookies.

If you like making your own ice cream, the recipe I love is for roasted strawberry and buttermilk ice cream from Jeni Britton Bauer of Jeni's Splendid Ice Creams. Her tip is to never include pieces of fresh strawberry in the ice cream. You'll break a tooth on a strawberry rock. Instead, roast them with a bit of sugar at 375 degrees to coax out their sweetness and then puree before adding to the ice cream base. Easy to make and divine to eat. Swirl the leftover puree into hot cereal to jazz up breakfast or add a few tablespoons to seltzer for a strawberry soda.

The first jam I ever made was strawberry. It is a classic. Author Kevin West began his canning adventures with strawberry, too. The well-illustrated recipes in his book *Saving the Season* turned me into a confident jam maker.

Strawberries.

Drizzle berries with a tart balsamic vinegar reduction, a dollop of ricotta cheese and freshly ground black pepper. I serve this as an appetizer or a dessert depending on my mood. Try tossing them with herbs—basil, mint or tarragon in salads, ice pops or sorbets. Chocolate, black pepper and almonds are also good partners.

Kimarie Santiago of Long Valley rolled out a Tickled Pink strawberry-flavored sea salt in her Saltopia line. Try rimming a strawberry margarita with Tickled Pink. Or make a strawberry smash with muddled berries, white rum, lime juice and simple syrup. Santiago likes to make a strawberry poppy seed salad dressing by using a blender to combine fresh strawberries, red wine vinegar, ground mustard, poppy seeds, canola oil and a pinch of her salt.

Be spontaneous and stop when you spy a stand touting these gems. It's a long, long time to wait until next season. If you went a wee bit overboard, simply give them a rinse and freeze them. They will be excellent in smoothies and fruit purees.

Don't just toss those strawberry tops. A friend's chickens always enjoy getting them for a little treat. But they don't have to feed the birds. The leafy shoulders can be used to make teas, infused waters and even flavored vodka.

Part IV

Summer

BASIL

If basil were a dancer, she'd be the belle of the ball. She has a vibrant personality, the ability to get along with just about everyone and stamina. She's a star. Just please don't be too rough when you swing her around or her leaves will bruise.

Basil likes to make a grand entrance right before showtime. Snip some leaves over a pizza right as it comes out of the oven or swirl some into a pot of soup right before you begin to ladle it out. Aromatic oil will release as the leaves hit the heat. Add basil to melting butter when you make garlic bread. Basically, add basil to anything right now and you can't lose.

Liven up lunch with a better BLT. Use a food processor to blend basil into mayonnaise before slathering on toast and layering on crisp lettuce, smoky bacon and tangy tomatoes.

We often gravitate toward Italy for inspiration when cooking with basil. It is officially time to break out those Caprese salads. A dollop of pesto inside a grilled mozzarella sandwich on hearty bread makes a midday meal memorable. Pick up a ball of mutz from Hoboken Farms at one of the twenty-five markets it covers.

Thai food is adept at coaxing the licorice notes from the herb and feels light for a summer supper. Green curry with seafood comes together quickly and

combines sweet brininess from the sea, creamy coconut milk and vivacious herbs. I'm partial to mixing it up with mussels, clam and squid.

Play with the more unusual varieties of basil—lemon, cinnamon or purple ruffles. Use it in a simple syrup for cocktails. At the end of the summer, I dry basil by the armfuls. It makes a great herbal tea.

Prep up for winter by portioning pesto into ice cube trays. Transfer the cubes into a plastic baggie. They will come in handy to add a little oomph to pastas, omelets, soups and salad dressings in winter.

Infuse basil's assertive flavor in an oil that you can stash in the pantry and use whenever you need a splash of summer. Drizzle it over grilled halloumi cheese and watermelon now and over mashed potatoes in the fall.

For dessert, marry basil with peaches, cherries or plums in a compote. For an absolutely perfect ending to a late summer meal, I make basil ice cream. I steep the herb in warm cream to capture its flavor before spinning it into a delectable frozen treat. If you are an overachiever, sandwich it between two other ice creams with contrasting colors and complementary flavors in a frozen terrine.

Blackberries

I have to admit that I always look forward to pairing my blackberry purchase with a little harmless flirtation with Antoine at Von Thun's Country Farm Market's stand. His customer service makes their blackberries sweeter than the rest. Try them for yourself at the Metuchen and Ridgewood Farmers' Markets.

Consider buying more berries than your recipes call for because, let's face it, snacking happens. And more snacking leads to more harmless flirtations. What? Isn't getting to know your farmer what this is all about?

Partly cloudy days in the low eighties are perfect for going blackberry picking. Grab your sunscreen, a hat and a bucket and hit the road. Visiting a U-pick farm, such as Von Thun's farm in Monmouth Junction, is a great treat for kids and grown-ups. As you walk down a dusty trail toward the field, your troubles disappear and you focus on what you went there for—big juicy berries.

If you are up for a really wild adventure, the Skylands Visitor website offers tips for finding berries in the wild in and around northwest New Jersey. Looking out for thorns, bears and snakes make the proposition a bit wilder than some, such as myself, may be up to doing.

Blackberries.

Don't worry if you don't have the time to go picking or the courage to stare down a bear in the process. There are plenty of turquoise pint containers full of these dark, delicious jewels ready and waiting for you at the farmers' market.

Perhaps you'll make lemon ginger cake with blackberry curd filling or rich chocolate cupcakes with blackberry swirl frosting. You can't go wrong with a classic blackberry crisp topped with toasty oats.

Not into spoiling your supper with dessert? Bring the berries into the entrée round. A quinoa salad with grilled chicken, nectarines and blackberries will be even better as the following day's lunch. Breakfast for dinner is always a fun switch. I vote for hot biscuits with lavender blackberry jam and thick slices of ham from a local farm.

Remember, berries are extremely perishable, so plan accordingly. It is no fun to bring home a big haul and let them go to waste. In the event you don't get to make the recipes you planned, just pop them in the freezer to use at a later date. Give them a rinse and dry on paper towels. Arrange them in a single layer on a parchment-lined tray and freeze until firm. Then package in freezer bags.

Making a quick blackberry syrup will also help preserve their flavor and use up any that are a bit squishy. Use it in a blackberry spritzer, as the base of a fruity cocktail or drizzle it over ice cream, oatmeal or yogurt.

I'd love to make blackberry gelée candies one day, but I keep eating all my blackberries up before I can make them. Darn, I'll just need to go see Antoine again.

BLUEBERRIES

Of all the fruits, blueberries make me most nostalgic for my childhood. My grandparents would take me to a farm called Blueberry Acres and bring home ten-pound boxes of sugared frozen berries to use over the course of the year. I would wait patiently for my Grams to get involved in chores in the bedroom and then make my sneaky move. I'd slowly creep to the chest freezer, hoist the lid, plunge my hand into the box of frozen berries and then scurry off to privately eat each frozen orb.

In an attempt to recapture my youth, I usually pack a cooler and a group of friends into the car for a road trip to Emery's Berry Patch in New Egypt. After spending a few relaxing hours picking berries in the field, twenty or thirty pounds usually make it back to the kitchen with me.

New Jersey is actually where the highland blueberry bush was cultivated from tiny wild specimens into the plump berries we know today. Visit Hammonton, the "Blueberry Capital of the World," to pick your own at DiMeo's Fruit Farms or for the annual Red, White and Blueberry Festival, where you can enter a blueberry pie–eating contest.

Blueberry pancakes are one of my husband's specialties. Use your favorite pancake recipe, spoon the batter into the pan and add a smattering of berries before turning the pancake. During blueberry season, we'll have blueberry pancakes for dinner once a week. If you happen to be in Atlantic City for brunch, order the Hammonton Stack at the Continental.

For a weekend breakfast, we make plain pancakes and blueberry compote to spoon over top. Simply put a pint of blueberries, the juice and zest of half a lemon, a half cup of sugar and one cup of water into a saucepan. Bring to a boil and cook until berries soften. If you'd like it thicker, make a cornstarch slurry. In a small bowl, make a paste with two tablespoons of cornstarch and two tablespoons of cold water. Add it to the berries and return to a boil until you reach the desired consistency.

Blueberries picked at Emery's Berry Patch.

A few blueberry recipes have become new staples for me. A Blueberry Cornmeal Skillet Cake from *Vintage Cakes* by Julie Richardson feels old-timey and is impossible to mess up. I add local honey and cornmeal to the New Jersey blueberries for my go-to summer potluck dessert.

The batter for the blueberry muffins in Thomas Keller's *Bouchon Bakery* is made the night before and then scooped and baked just before you need it. Perfect for bakeries, this method is also a timesaver for busy moms. Make a double batch and freeze half. Last-minute summer house guests will thank you.

One of the reasons I decided to attend Promise Culinary School in New Brunswick was its commitment to farm-to-table. When I met culinary school director and chef Pearl Thompson for the first time, I knew it was the place for me after hearing her speak passionately about making sure all people have access to local food. Each season it hosts a series of affordable farm-to-table tasting events. I was proud to participate in many of them during my time there as a student and then staff member at Elijah's Promise.

At the end of a dinner celebrating the herbs grown by the Master Gardeners of Middlesex County in the display gardens at the EARTH Center in South Brunswick, I rolled out a cooler. Inside were ice pops made with blueberries from Emery's and tarragon from the very garden over which we were watching the sun set. Sticky fingers and slurping noises ensued.

I plan to make blueberry jam this year. Martha Stewart's Blueberry Bonanza Bars are one of my all-time favorite cookies. Using great homemade jam will only make them better. If making your own jam is never going to happen, then by all means enjoy some by Jams by Kim instead. The company's founder, Kim

Osterhoudt, told me that the secret to making her blueberry and lemon jam is the berries she uses from Phillips Farm in Milford. They both sell their wares at the Summit Farmers' Market. You can also find Phillips at the Hunterdon Land Trust Farmers' Market in Flemington.

One of the reasons I love blueberries is that prep is minimal to get them tucked into the freezer for future use. Quickly rinse them and remove stems. Pat dry. Loosely lay them out flat on a sheet tray. Roll in sugar, if you like, but it is really not necessary, and pop them into the freezer until they are individually frozen. Then transfer to freezer bags.

A timesaving tip is to either measure them or weigh them at this point, so you can grab a bag and know that it contains two cups, three pounds or whatever quantity you choose. Label and date the bags. If you invite me over, don't be surprised if a bag ends up a little light. I'll nick a handful as soon as you turn your back.

CANTALOUPE

I adore a ripe cantaloupe. Warm from the sun, they exude a heavenly fragrance as they fatten up on the vine. The melons available at supermarkets are picked far before they are ripe, and when you lug one of those bowling balls home, you can only hope for the best. At the farmers' market, the melons have just been picked. The vine end of the melon should yield slightly to the press of your thumb. It should smell ripe. Go ahead, lean in for a sniff—those are completely free. And of course, it is the best advertisement for them. Who can resist that divine smell?

Cantaloupe is an ingredient I never saw my grandfather fuss with. He'd sit down with a fat wedge, mysteriously sprinkle it with salt and dig in with his spoon. As a child, I thought adding salt to what I perceived as a dessert was counterintuitive. (This was long before the "salted caramel everything" trend.)

A bit of salt will accentuate the sweetness of cantaloupe. In Italy, paper-thin slices of prosciutto are wrapped around sliced melon for one of the best antipastos of all time. Nirit Yadin, a culinary educator and the market manager at Princeton Forrestal Village Farmers' Market, suggests combining cantaloupe, sheep's milk feta cheese and pomegranate molasses. Pomegranate molasses can be purchased at the Savory Spice Shop in Princeton or Westfield or at Middle Eastern markets.

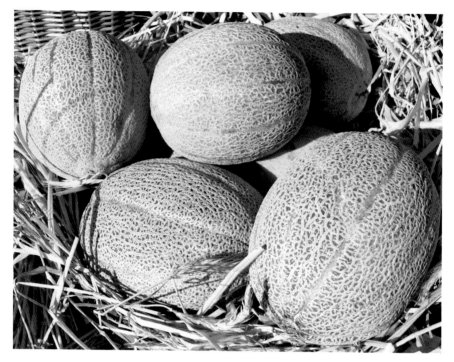

Cantaloupes.

Pick up a chicken from your local farmer and use the legs and thighs in five-spice chicken with a basil and cantaloupe salad. Soy sauce, lemongrass, basil and five-spice powder add salty, herbaceous and earthy notes to a marinade that will offset the melon's sweetness.

While you're making dinner, flip through your dusty vinyl collection and find Herbie Hancock's excellent jazz track "Cantaloupe Island" to bop along with while you chop.

I love to drink *agua frecsa* in the summer. Lightly sweetened pureed fruit is brightened with a squeeze of lime juice and thinned with a bit of water. Once you try a cantaloupe agua fresca, you'll lay off the lemonade.

The webbed netting on cantaloupe rind can harbor bacteria. Give it a good rinse before you cut into it. To easily remove the rind, slice off the top and bottom and stand the melon on one flat end. Working from top to bottom, carefully remove the rind in strips. Store ripe melon in the refrigerator for up to three days.

CHERRIES

The simple joy of a bowl of cold cherries is one of summer's best treats. Sweet and tart varieties are available for a very short window, so grab some while you can. Cherry season is short and sweet.

After I buy sweet cherries, I can't resist pairing them on a cheese plate with Buttercup Brie and Rosedale, made by Cherry Grove Farm in Lawrenceville. Look for the farm at the Bordentown, Highland Park and West Windsor markets.

My baking-obsessed friend Nychey races to the farmers' market every July to snatch up sour cherries to make cherry pie. Bring one to a Fourth of July party and it will disappear as quickly as the fireworks in the sky.

Dessert options abound. Cherry cheesecake is a favorite, but commercial cherry topping is lacking in the flavor department and artificially colored. Make your own compote to dollop beside pound cake, ice cream and anything chocolate, such as Black Forest cake.

On Bastille Day, practice your French and pastry skills with *clafouti*, a baked custard studded with pitted cherries. Pitting cherries can be a chore. Invest in a cherry pitter if you plan to make lots of cherry dishes in the future. There are probably a few things around the house that can be used as a stand in for a pitter, too. Knitting needles, chopsticks and pastry bag tips will work in a pinch.

Cherry is one of the most popular Italian ice flavors. Try making your own. Then you won't have to go stand in line in the heat to get some. In a power blender, process a pint of pitted cherries, two cups of ice, the juice of a lemon and sugar to taste. Put the smooth mixture into a 9x9 metal pan and freeze until you are ready to serve. Scrape with a fork to fluff the ice crystals.

Farmers have to fight off the birds before they can scamper up tall ladders to handpick the pendulous fruits. On the Terhune Orchards website, Gary Mount has written an account of what goes into growing cherries on his farm in Princeton. It makes the price per pound for cherries completely understandable.

Purchase a few extra pounds to freeze. Dehydrating also amplifies their sweetness. Dried cherries are a wonderful way to bring the taste of summer to winter baked goods. I usually make biscotti with dried cherries and pistachios for holiday gift-giving.

Corn

As I passed the corn display at a farmers' market, I heard a *squeek, squeeek, squeeeeeeeek*! A gentleman was busy peeling back the husks of corn and tossing them back in the pile. He turned to me and said, "I have to check to see if they are good."

I replied, "Don't worry, all the corn is good here. You don't have to do that." And then I held myself back from getting into an unsolicited produce lesson and reluctantly walked away.

Corn is magnificent. How does it know to grow the kernels in rows? How do the husks know to wrap themselves around the body like a sarong on a beautiful woman? It just knows. Just as we know it will be delicious. But there is still that little nagging voice that whispers like a breeze in a cornfield: "Peel, peel, peel."

I visually inspect an ear of corn to make sure it is not dry and press on the tip to feel the kernels. Then into the market bag it goes. As soon as the husk is compromised on corn, a countdown clock starts. That corn needs to be cooked fast. Farmers will tell you they put on a pot of water to boil before going out to get corn for their supper.

My grandfather particularly loved fresh sweet corn, and we'd have it every which way. Corn fritters were one of my favorite summer lunches growing up. Crisp on the outside, soft in the middle and studded with corn kernels, they are great with syrup, jam or even peanut butter (my topping of choice as a kid). Today, versions with a kick are exciting me. Try *Tod Man Khao Pod*, a red curry–laced, Thai-style fritter.

I doubt my Pop-Pop ever had *elote*, Mexican grilled corn, but I know he would have loved it as much as I do. After grilling the corn, it is coated with mayonnaise, crumbly *cotija* cheese, chile powder and a spritz of lime juice. For a big cookout, prep them ahead and wrap individually in aluminum foil.

Our family road trips when I was a kid often led us to Lancaster, Pennsylvania, for family-style Amish meals. I couldn't get enough of the communal dining experience or the chow chow, a sweet and tangy condiment. It zings alongside country ham or a roasted chicken. I like to put up a few jars each year.

Chowder is one of the best ways to showcase corn. Simple and homey, it hits the spot. Get elevated by adding ingredients like specialty mushrooms, fingerling potatoes and crab meat. I like mine with big chucks of lobster, too.

Sweet corn ready for grilling or boiling.

My southern Grandmomma, Carlie, makes succotash as a side dish with fresh lima beans and corn from her garden. She serves it with chicken and dumplings. I have dreams about this meal.

Dessert is a great way to feature corn's inherent sweetness. When I see corn ice cream on the menu at the Bent Spoon in Princeton, I can't pick my spoon up fast enough.

All of your corn recipes will be great. I promise. No peeking under the husk necessary.

CUCUMBERS

I was on the phone with my friend Jacquelyn as she arrived at the Madison Farmers' Market. "Ooh, look at the little babies," she cooed into the line. I paused and envisioned chubby-cheeked cherubs in a pram. Then she dashed my mental image by explaining that she'd just run across the most adorable display of cucumbers. Yes, I choose my friends based on their ability to get all gushy about vegetables.

Cucumbers from Phillips Farm in Milford.

Julia Child's recipe for baked cucumbers in *Mastering the Art of French Cooking* may initially cause one to balk. Hot cucumbers? Julia, are you quite sure? But it actually makes sense to draw out moisture and be left with silky texture and deep cucumber flavor.

Panang cucumber curry is a quick stir-fry of long ribbons of cucumber, tofu, veggies and coconut milk in a Thai dish that offers mild to medium heat. It is really good. If you firmly believe cucumbers are best served cold, that's cool. Every summer I get a craving for lobster rolls. For extra crunch, fold diced cucumber, fresh tarragon and scallions into a creamy lobster salad. Serving on a toasted bun is a must.

Practice your sushi rolling skills with *kappa maki*, thin strands of cucumber at the center of sushi rice and seaweed. Once you've mastered the technique, add salmon or other fillings along with the cucumber.

Raita is a creamy Indian condiment that cools down spicy flavors with yogurt and cucumber. You'll need some on the side with fiery lamb *vindaloo* made with meat from Cherry Grove Farm.

As I weigh my cucumber-centric menu options, I like to sip a Pimm's Cup cocktail. The low-alcohol drink brimming with sliced cucumbers, citrus and strawberries is the perfect thing to sip while watching Wimbledon or U.S. Open tennis matches.

EGGPLANT

Eggplant has a devoted following around the world. Depending on how it is prepared, eggplant can be meaty, velvety smooth or smoky. It takes on flavors so easily; cooks around the globe favor it. I teach a class called Eggplant's World Tour with eight very different preparations.

At the market, you may choose the classic large black eggplants or be wooed by lovely violet, white or striped varieties. Their flavors are all very similar. Choose whichever appeals to you. The Asian varieties are perfect for slicing in half lengthwise and grilling or sautéing.

Former *Gourmet* editor and Lambertville resident Kate Winslow explored eggplant's many incarnations in Sicilian cooking while she and her photographer husband, Guy Ambrosino, spent a year in Sicily working on *Coming Home to Sicily* with Fabrizia Lanza, who owns Case Vecchie, the renowned cooking school that her mother founded in Sicily.

Several varieties of eggplant.

Their recipe for *caponata* is sublime. The cooked salad of golden brown cubes of eggplant, celery and tomatoes is sweetened with fruit, brightened with a pop of vinegar and salted with olives. Put this out with some good bread, cheese and a bottle of wine for a light lunch on the patio with friends.

My world tour has a stop in the Middle East for *baba ghanoush*, the creamy tahini-spiked dip made of the flesh of eggplant charred over flames until the flesh is tender. Montclair-based Chinese cookbook author Eileen Yin-Fei Lo chooses the long, slender variety for her eggplant with garlic sauce.

One of the best aspects of running a community café was having members from the community volunteer to help in the kitchen. One day, Shalini Sevani walked into the kitchen and offered to cook some Indian items as lunch specials. Collaborating with her was fantastic. After volunteering for some time, she decided to enroll in Promise Culinary School and went on to work as the cook at a nursing facility. One dish she made for us frequently at the café was *baingan bharta*. The eggplant is cooked whole similarly to *baba ganoush*. Then it is cooked with tomatoes, onion, garlic and ginger until it becomes soft and glossy. At this point, fold in fresh cilantro. She made many

Breaded eggplant cutlets produced from Jersey Fresh produce from Flaim Farms in Vineland.

of the homesick Rutgers graduate students from India who were our regular customers very happy with her food.

For a Greek spin, moussaka is a hearty dish layering eggplant, potatoes and beef cooked with spices. A last layer of béchamel sauce goes on before baking until bubbling and brown.

Choose firm eggplants with shiny, smooth skin. Store for up to a week in the refrigerator. If you'd like to freeze eggplant, it must be cooked first. I will oven-bake breaded slices, which I can quickly layer with tomato sauce and cheese to make eggplant parmigiana whenever I want a comforting casserole in the winter—which is, admittedly, quite often.

Flaim Farms has frozen breaded eggplant cutlets available at its stand at the Collingswood market and several local retailers.

GRAPES

Right around Labor Day, Terhune Orchards in Princeton started posting tempting photos of grapes on its Facebook page. I called the farm store that morning right as it was opening. I was told enthusiastically that the store has green and white seedless varieties and to "get here soon because they are going fast."

Table grapes grow well in New Jersey, but the supermarket is usually stocked with bunches from California or Chile. This is why I reach for my car keys for a fast getaway on a Sunday to Terhune's or anywhere else I can grab a bunch. They sell so fast that sometimes they don't even make it to the farmers' markets. For those of you who really want to get your feet wet while exploring New Jersey's grape scene, head to the Grape Stomping Celebration at Laurita Winery in New Egypt.

Eating grapes out of hand is a simple pleasure, but cooking with them also has its rewards. Pan-roasted grapes with sausage over creamy polenta is a delight and quick to make. Get out your granny's cast-iron skillet and brown some sausages. Then add grapes, some stock or wine and herbs. I put this recipe in heavy rotation, alternating between using locally produced chicken sausages from Griggstown Farm and wild boar, lamb or rabbit options from Newark-based meat purveyor D'Artagnan.

Celebrate scoring some fresh grapes like a winemaker would with a flatbread pizza topped with blue cheese, grapes and honey. *Ajo blanco* is Spain's clever chilled soup that combines stale bread, almonds, garlic, water,

olive oil and grapes. Tumble cherry tomatoes, grapes and jalapeños together for a late summer salsa.

Grape leaves are also possible menu items. Indulge in grape leaves stuffed with ground meat and rice from New Jersey cookbook author Poopa Dweck's *Aromas of Aleppo: The Legendary Cuisine of Syrian Jews.*

Hauser Hill Farms from Old Bridge also uses Facebook to flash glimpses of its grapes on the vine during the growing season. Look for it at one of the farmers' markets it covers, including Freehold, Keyport, Rahway and Red Bank.

NECTARINES

Underneath the nectarine's fuzzless face lies the same succulent sweetness of a peach, with a seed at its heart that skips to a similar beat. Essentially, they are same fruit, with a slightly different genetic composition that gives peaches fuzz and leaves nectarines smooth. One fruit grower told me recently that peaches pay the bills. Nectarines get a little lost in the background unfortunately.

They can be swapped for peaches in most recipes. Battleview Orchards in Freehold has recipes on its website for a cobbler and a Nectarine Brown Betty that captures the sweet juices mingled with butter in hunks of stale bread. Keep this idea for Tuesday or Wednesday's dessert option. It is a great way to use what is left from your weekend farmers' market haul.

Making a fruit tart is a breeze if you use frozen puff pastry or phyllo dough. Slice the nectarines and tile them on the base. If you are feeling more creative, use individual tart pans and curl the nectarine slices in concentric circles so that they resemble a rose.

Nectarines or peaches benefit from a quick turn on the grill. Top them with a dollop of local jam, whipped cream or ricotta cheese for a light dessert. Grill more than you need and use them chilled in a salad.

Robson's Farm in Wrightstown has been farming since 1932. There they know a thing or two about how to use nectarines. Rose Robson is working toward becoming a certified Master Preserver and often shares her recipes on the farm blog. Her white nectarine pickles are tantalizing. With a jar of those in my fridge, I would be caught red-handed raiding them in the middle of the night.

I made a stone fruit slaw at a cooking demo at the Highland Park Farmers' Market a few years back. I added spicy Sriracha to julienned nectarines, peaches, scallions and spices. This works especially well if the fruit isn't quite

soft enough for eating out of hand. Use a mandoline to get nice thin slices and then cut by hand crosswise.

Store nectarines at room temperature until ripe. They will yield slightly to a firm touch. When ripe, they may be stored in the refrigerator for up to a week.

OKRA

If you aren't a transplanted southerner, your nose probably wrinkles up when thinking of eating okra. "Eww. It's slimy," people say dismissively. I counter that you just haven't eaten it cooked the right way.

Last summer was all about pickled okra for me. In June, I spent a few days with southern cookbook authors Matt and Ted Lee at their Cookbook Boot Camp to work on a book concept. At a cocktail party to welcome participants, they served a spread of southern delights—their butter bean pâté, country ham and tender spears of okra pickled in a smoky brine. I couldn't stop eating them.

A few weeks later at the Summer Fancy Foods Show in New York City, I had the pleasure of snacking on more of them at the Rick's Picks booth. Its Smokra has a bit of crunch, a whiff of smoke and nary a sign of slime. I tracked them down at a local shop and have been hoarding a jar in my fridge for afternoon snacking. I love them cold with a bit of bread and cheese. I spent an embarrassing amount of time trying to figure out how to make my own version at home. Ultimately, I decided that because Rick's Picks sources its okra from New Jersey farms whenever possible, I'll source my pickled okra from it whenever the mood strikes me.

I always order *bhindi masala* if it is on the menu at an Indian restaurant. In this preparation, the okra is softened by acidic tomatoes and enhanced by the heady blend of spices in *garam masala*.

Okra is mostly associated with southern cuisine. Seeds were carried to America from Africa on slave ships. The plants fared well in their new climate. (They grow like gangbusters here in the Garden State, too.) In African languages, okra is called *ngombo*. The Creole favorite we know as gumbo derived from recipes brought from Africa that tapped into the mucilaginous quality of okra to thicken soups and stews.

Culinary historian Jessica B. Harris caught my attention on television in the '90s when her *The Africa Cookbook* was published. I've been a devoted

Okra from Kernan Farms in Bridgeton.

reader of hers ever since. I'm particularly interested in all the ideas for okra. Ethiopians serve a sweet and sour dish with honey and lemon tossed with seared pods. An amazing stew with shrimp, crabs and okra could certainly make a believer out of an okra skeptic. If all else fails, super-crunchy fried okra will do it. Giving them a dunk in buttermilk and a roll in cornmeal will make the pods tender and crunchy simultaneously. Yum!

When shopping for okra, look for firm pods no longer than your fingers that are green and unblemished. Use in two to three days. Excess can be frozen after blanching and shocking. If you plan on using them in gumbos or stews, slice before freezing.

PEACHES

If we were to line up all the fruits and vegetables grown in New Jersey for a yearbook photo, peaches would be voted "Most Likely to Get Along with Everyone." I can't think of a meal or course in which they wouldn't be welcome.

August kicks off with a bit of peach mania. The New Jersey Peach Promotion Council lists scores of events around the state for peach pie

contests, festivals and tastings. My friend Cynde called me to report from a peach festival held at a church in Point Pleasant. "They have peach Melba and cobbler and ice cream and pie and…next year, I'll have to not eat lunch before I come here," she gushed. Yes, and call to invite me along before going, not after you arrive to make my tummy grumble at the descriptions.

Those classic dessert options Cynde found are also joined with new and exciting ones. Peach empanadas made by the students at Promise Culinary School were selling briskly at the New Brunswick Community Farmers' Market. Sweet and spicy peach Sriracha sorbet at the Bent Spoon in Princeton is one of the best desserts I've ever had.

I was thrilled to help judge a peach pie contest at the West Windsor Community Farmers' Market. After much deliberating and chewing, we declared the winner—a vegan pie made by college student Emily Meshumar. She went on to the state level contest held at the Frog and the Peach in New Brunswick. She won the grand prize for the north region with her pie, which substituted coconut oil for butter in the crust.

Peaches are brilliant in savory dishes. They can be the surprise sweet element in barbecue sauce. Slather it on some ribs and you won't be sorry.

A basket of fresh Jersey peaches.

Peach-lacquered chicken wings are a good way to use up the last bit of peach jam you picked up at the farm stand. Substitute peaches for mangos in recipes for salsas and chutneys.

Chilled peach soup with yogurt and cardamom is always a hit when I serve it. Halve and pit three pounds of unpeeled peaches. In a stockpot with the juice of one lemon, cover the peaches with water and simmer until soft. Puree and chill. Sweeten with honey and add plain yogurt. Add a dash of ground cardamom.

My friends and I make a ritual of going out to pick a bushel of peaches to put them up for winter. A long weekend is the best time to get out there under the long, feathery peach tree leaves and reach out for the perfect peach. Admittedly, being out in the field and then blanching, shocking, peeling and slicing almost fifty pounds of peaches can be hot and time-consuming. Having a group to do the work together really helps.

Quench your thirst while you work with peach iced tea. Take a soft peach and put it in a sauce pan with ten black teabags, cover with boiling water and steep for ten minutes. Strain into a pitcher and sweeten to taste.

Allow peaches to ripen at room temperature. Speed the process by putting them in a paper bag. Once ripe, they can be stored in the refrigerator. Peaches may be frozen whole, halved, sliced or pureed. I prefer slices for future pie and cobblers, puree for ice cream and sauces.

PEPPERS

I'm not much of a risk-taker in normal life, but in the kitchen, I like to walk on the wild side. Cooking with peppers can be the culinary equivalent of Russian roulette. I proudly claim that I can eat fire and sample peppers that make others break out in a sweat just thinking about it.

At Elijah's Promise, we got a delivery each week from the Master Gardener's demonstration garden at the EARTH Center in South Brunswick. Often a sack of peppers arrived. We circled the bag cautiously. Some of the peppers in there were obviously hot—orange habaneros, tiny red chiles and fat jalapeños. Others were not so clear. I would volunteer to taste them before we used them. None of them went to waste. One chef experimented with making hot sauce. Chef Armando Miranda taught me how to pickle jalapeños with carrots and onions. It's a Mexican staple that goes well with anything that needs a little zing.

He also taught me how to make his poblano and almond soup. Amazingly creamy and flavorful, roasted, peeled and deseeded mild poblano peppers are simmered with almonds and pureed. It just happens to be vegan, too. Poblanos are also great for *chile rellenos*. They are also peeled. Seeds are removed carefully through a slit cut in the side. Then they are stuffed with cheese, dusted with flour and dipped in an egg batter and fried. We taught a group how to make them during a workshop.

One of my favorite peppers is the unpredictable *pimiento de padron*. Simply blistering them in a hot pan with some good olive oil and a shower of salt is a typical Spanish tapas dish and great way to start a meal and a conversation as guests report on whether they got a hot or mild one.

If you like your peppers sweeter, never fear. Roasted red and yellow pepper purees create a dramatic base on the plate. Make up a big batch now and freeze for future use. These purees can be served as a soup, a pasta sauce or a pan sauce served with meats.

Sweet and Italian frying peppers.

Stuffed peppers are a classic way to use up a bumper crop. Jazz up the fillings with polenta and sausage stuffing, goat cheese and mushrooms, ground lamb and feta, chorizo and brown rice or quinoa and French lentils.

One of New Jersey's claims to culinary fame is the Italian hot dog, a hot dog fried in oil, smothered with peppers, onions and potatoes and stuffed into pizza bread. This is not your ordinary backyard hot dog. According to dog lore, Jimmy "Buff" Racioppi began serving his wife's invention at card games in Newark in 1932. They were so popular that they led to a family business. Jimmy Buff's has been serving the Italian hot dog for more than eighty years. Have fun trying to replicate one at home or just jump in the car and visit Jimmy Buff's in West Orange or Kenilworth for a little "research."

I prefer my Italian frying peppers in a pepper, egg and potato sandwich on a good Portuguese roll. Jimmy Nardello or Marconi peppers are a great choice for these.

When handling hot peppers, you may want to wear gloves. Remove the seeds and ribs if you are concerned about the heat. Select firm peppers without bruises or spots. Store them whole for two to three weeks in the fridge. Once cut, use within two to three days.

Plums

The summer I worked at Brandl. in Belmar was a terrific learning experience. Chef Chris Brandl started out working for chef Toni Froio at the Farmingdale House. She is well known for her authority on Northern Italian cuisine, her mercurial temperament and exacting standards. Once a month she came to Brandl. for a special dinner that sold out every time. I was fortunate enough to be assigned to prep for her. We'd spend all day on Monday in the kitchen together. She taught me how to make *agnolotti*, *spiedini* and *zabaglione*. All from scratch. Everything had to be perfect. Every plate had to be the same. I loved every second I got with her. She liked me mostly because I didn't mind doing the dishes.

One dish I picked up from her was pan-roasted plums. A hot sauté pan, a perfect plum, a little clarified butter and a sprig of thyme are all you need to add to the pan. Serve these plums as a first course, chilled or warm, over greens. Years later at the café, I added a star anise gastrique as my twist.

When I left Brandl. to go off and be the chef at A Better World Café with very limited experience, of course, that sounded like madness. "You're not going to make it," chef Toni clucked at me while shaking her head. I can still

hear her in my head whenever I get down, and it makes me want to prove her wrong. She's always been a fighter, and I am, too.

I had a wonderful celebratory dinner with a group of friends at Elements in Princeton. Our host, Sandy, and another guest, Susan, enjoyed a salmon entrée with pureed satsuma plums, pine nuts, bok choy and mushrooms. I had to mind my table manners and not reach across the table to sneak a bite of the garnet goodness.

The satsuma plum is a Japanese variety that is red, firm and juicy. It is wonderful to eat out of hand. Watch out for the juice that tries to trickle down your arm. I am partial to yellow Shiro plums. I can't seem to pass them by if I see a quart at a farmers' market stand. Look for plums from Phillips Farm and Melick's Town Farm.

Once you get home, fire up the grill and get those plums on the fire to make black pepper–encrusted duck breasts with grilled plums. The slight tartness of plums will cut through the richness of the duck. Plums also pair well with beef, lamb or venison.

Pork and plums also make a happy pairing. Soy, ginger and five-spice powder add an Asian twist to braised pork with plums. The scent will drive you mad as it cooks slowly in the oven on a Sunday afternoon.

Yellow plums.

I had the good fortune to stumble upon Italian prune plums grown at the farm owned by Dearborn Market in Holmdel. Since acquiring a dehydrator, I have experimented with drying just about anything that comes across the kitchen counter. I loaded it with a few pounds of prune plums. First I blanched and shocked them to split their skins. Then I cut them in half lengthwise and removed skin and pits before drying them for five hours. These were the best prunes I've ever had. I hope to get another batch put away to use in winter baking. I'm dreaming of tucking some prune *rugelach* into my holiday goody bags.

Roasted plums with vanilla beans are a good thing. Simply cut, season and caramelize in the oven for a perfect topper for ice cream or cake. We can't stop ourselves from eating them immediately from the pan. This method is great for pears and nectarines, too. Change up the seasonings to suit your mood. A sprinkle of cardamom and ginger makes a weeknight dessert feel special.

Ripen plums at room temperature. They will yield to the touch when ripe. The softer they get, the sweeter they will be. Be patient. After ripening, store in the fridge for up to a week.

SWISS CHARD

Swiss chard is a nutritional powerhouse with the added benefit of not having the bitter or peppery taste that deters some from eating other kinds of leafy greens. Large paddle-shaped leaves spring from stalks that can range in color. The Bright Lights variety produces bundles of red, yellow, orange, pink and white stemmed leaves that make you happy seeing them stick out of your farmers' market tote.

Its mild flavor makes it easy to swap for spinach in any recipe. If you are just dipping into cooking with greens, give your old standby spinach dip some new zip with Swiss chard *tzatziki*. Add some pita chips, an assortment of olives and a wedge of cheese for a platter of munchies to share with friends.

The larger leaf size and their sturdy nature make them ideal for filling. Fresh mozzarella, basil and slices of tomato wrapped in leaves and then grilled are addictive little bundles.

Pizza Rustica, a savory pie, packs mushrooms, cheese, eggs and Swiss chard between a double crust. It is tasty at any time of day, warm or cold. I like to pack it for a picnic.

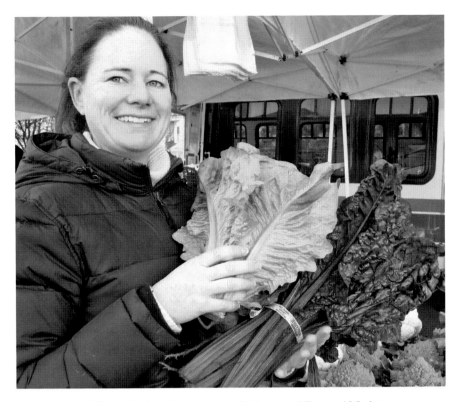

A customer with Swiss chard and lettuce at the Collingswood Farmers' Market.

Sautéed Swiss chard is more luscious than other greens and makes a lovely bed on which to perch any protein. Vic Rallo pairs it with oven-roasted branzino at Unidici Taverna Rustica in Rumson. Try it with salmon, short ribs, lamb chops, grilled chicken or pork tenderloin.

Top crispy baked polenta squares with Swiss chard and cherry tomatoes for a quick weeknight dinner option. Top with a farm-fresh poached egg, garlic shrimp or sliced spicy sausage. Spice up the grill with Swiss chard and horseradish served with barbecued beef brisket or chicken wings. Vegetarian tacos filled with a combo of corn, chard and smoky chipotle peppers layer plenty of flavor onto warm corn tortillas.

The stems are completely edible. Use them in place of celery in soups. I usually slice them thinly and cook first before adding the leaves when preparing them.

Look for perky, green leaves with crisp stems. Keep refrigerated for up to one week.

TOMATOES

Any way you slice it, everyone knows that Jersey tomatoes are the best tomatoes. Tomatoes can take their sweet time ripening, but when they are finally ready, they arrive in full force. Teensy cherries, hefty plums and heirlooms in rainbow hues join the crowd favorite—the beefsteaks—at the market.

After I gorge myself on a simple sandwich of thick slabs of yellow mortgage lifter tomato drizzled with fried shallot oil and a scattering of herbs on toast, I have the strength to turn on the stove and tackle tomatoes.

Julia Child will be smiling over your shoulder as your prepare *Tomatoes a la Provencale*. Core and halve a big juicy tomato and scoop out the seeds. Season them with salt and pepper, top with minced garlic and fresh breadcrumbs and bake for about twenty minutes. Sometimes I like to hide little surprises of cheese inside, heat the garlic in oil first and then use the infused oil to dampen the breadcrumbs.

In the '50s and '60s, when French food was new to Americans, tomato aspic was very cool and ended up on many menus. I'd love to resurrect this jiggling gem encapsulating tomato's rich flavor in a gelatin base.

A quick tomato tart made with a base of phyllo dough or puff pastry is quick enough for a weeknight dinner. Make a few extra to freeze for future use. Lightly score the pastry with a one-inch border and then spread a base of ricotta, whipped cream cheese or goat cheese on the dough and layer on toppings. I like to alternate yellow pear tomatoes with thinly sliced, unpeeled zucchini for a colorful contrast. Or go find orange, yellow, pink and green tomatoes to vary with robust red slices.

Get creative with a batch of tomato sauce by inflecting it with chipotle peppers or curry spices. Either would be delicious served with chicken, pork or veggies.

I cook down as much tomato as I can at the end of the season to freeze for later. Quart- or gallon-sized bags of purees can be used in sauces and soups. I pack small eight-ounce containers with colorful roasted cherry and plum tomatoes. I like to add them whole to pasta dishes right before serving.

At a canning class with Kim Osterhoudt of Jams by Kim, students learned how to make tomato jam that was utterly fabulous. I recently started making a chutney with green tomatoes that just don't want to ripen at the end of the season.

I can't talk about New Jersey and tomatoes without highlighting First Field. I met Theresa Viggiano and Patrick Leger in 2008 when they were just starting out making small batches of a family ketchup recipe in the

Heirloom tomatoes.

kitchen at Elijah's Promise. As they grew their own tomatoes on a small farm in Kingston and bottled them into something this avowed ketchup hater grew to love, their business grew, too. Now they are able to support other small New Jersey farms by buying additional produce to keep up with the demand for their condiments. You can find them at the West Windsor Community Farmers' Market and on the shelves at many specialty stores and supermarkets around the state.

Store your tomatoes at room temperature. Place them stem side down on a tray. Do not crowd them together or pile them on top of one another. Eat or cook them within one to two days of bringing home. Jersey tomatoes are special. Enjoy every bite.

WATERMELON

I used to have a boyfriend whose mother deseeded and cut watermelon into uniform chunks for him. He was a bit shocked when we moved in together

and learned that I did not want to continue his mother's act of love. However, I did wholeheartedly agree with her that watermelons with seeds are better than those convenient (yet tasteless) seedless varieties.

When I want a watermelon, I go see Karley Corris from Jeff's Organic Produce in Monroe. The stand features organic heirloom varieties in a rainbow of colors. I shared a slice of their orange watermelon with my young friend Noah in late August. He deemed it the best of the summer and kept coming back for more slices, possibly ruining his supper. But who cares? A kid who loves fruit is a good thing. I'll take the heat from his mom.

Smoky watermelon gazpacho is one of my favorite chilled soups. Combining sweet melon, deeply flavored tomatoes, a flash of heat from chipotle, a shot of sherry vinegar and a hint of smoke from smoked paprika, it touches on every flavor you want in your mouth at once. Serve it before a rich steak for supper or with a crisp salad for lunch. I make it often for my summer cooking demonstrations.

The mouse melon, aka Mexican sour gherkin, is actually a cucumber that looks like a tiny watermelon. Juicy and flavorful, they will make a witty statement when you pair them with cubes of watermelon, *cotija* cheese, a

Watermelon and honeydews.

squeeze of lime and a pinch of chile in a salad. These are easily grown in New Jersey and showing up more frequently at markets.

A watermelon cocktail is one of our favorite ways to kick off the weekend at our house. Muddled watermelon, gin, Campari and citrus make a refreshing tall drink to sip as you soak in the last rays of the day.

Now that I've convinced you to buy a watermelon with seeds, don't just throw them out. Make a snack. The Japanese soak them in soy sauce and star anise before toasting in the oven.

The rind is also edible. Watermelon rind pickles are a fun weekend project. The best flavor of *kombucha* I've ever had was watermelon that used the rind and fruit.

Choose a watermelon that feels heavy. The skin should be smooth and unblemished except for a light yellow spot on one side where the melon rested on the ground. Melons without a spot may not be ripe enough. Give it a rap with your knuckles. A ripe melon will have a nice hollow ringing sound. Store whole watermelon in the fridge for up to a week. Once cut, use within two to three days.

ZUCCHINI

I dare you not to make zucchini bread this summer. When one of your gardener friends proudly presents you with a sack of summer squash; do not panic. Do not pull out your dog-tired zucchini bread recipe. Make something different.

Zucchini is a key component in *ratatouille*, the French dish that sweeps up summer's bounty and stews it down to its savory essence. Although ratatouille is traditionally made on the stovetop, I worked with a group of teens from Urban Mitzvah Corps volunteering at Elijah's Promise on perfecting an oven-baked version that could be cooked and frozen to serve guests at the soup kitchen during the winter. The teens sliced onions in half rounds, diced eggplant, sliced zucchini, chopped tomatoes and minced garlic and herbs. We drizzled the bottom of a baking dish with olive oil and layered in the vegetables, sprinkling garlic and herbs in between and on top. Covered with aluminum foil and baked for an hour, the vegetables released their juices and softened. Reheat uncovered to concentrate even more flavor.

For a quick weeknight supper, zucchini latkes will satisfy the urge for something crunchy and fried. Grate zucchini and potatoes, squeeze out

water and toss with a beaten egg and a bit of flour. Zucchini pickles are another good way to use up a bumper crop and are a little different as a zesty bite alongside any sandwich.

A good way to use up those really big zucchinis is zucchini Parmigiana. Slice lengthwise into half- to one-inch planks. Dredge in flour, dip in beaten egg and cover in breadcrumbs seasoned with fresh basil, salt and pepper. Instead of pan-frying, I like to bake these. Coat a baking dish with a thin layer of olive oil and arrange the breaded slices. Bake at 375 degrees for about twenty-five minutes, turning once halfway through cooking. The breadcrumbs should be golden and crisp. Layer with tomato sauce and cheese for a casserole you can bake off now or wrap and freeze for future enjoyment. Or cut the zucchini into fries and bake in the same method for a side dish kids will love.

Still craving that zucchini bread? Zucchini nut bread cookie sandwiches with a cream cheese filling rock my world. Give them a try instead. I dare you.

Part V

Fall

Apples

On the cusp of the holiday season, I ambitiously begin to think of baking apple pies. I imagine pressing the soft, cool dough into the pie plate, slicing apples and dusting them with copious amounts of sugar and cinnamon. I can almost smell the tantalizing aroma of the fruit and spice mingling under a golden brown crust.

Then I shake my head back to reality and ask my husband, who is a much more patient and capable pie maker than I am, to get out his apron. When I was little, I would stand on my tiptoes at the kitchen counter to watch my grandfather make apple pies at the request of my grandmother. I guess it is just a thing in our family for the ladies to stand back and admiringly watch the man of the house make pie.

My husband got his start on baking pies with Jamie Oliver's recipe for apple pie, which is quite easy for the beginner but adds a few touches to make the dough special. An egg for richness, lemon for brightness and a bit of confectioners sugar add up to a very nice crust. After you master this basic dough, move on to endless variations by fiddling with the crust or the filling. Try apple pie with cheddar crust or grape and apple pie, in which the fruit turns a surprising magenta hue.

When I have the opportunity to do cooking demos at the Highland Park Farmers' Market, I love to use fruit from Melick's Town Farm in Oldwick.

I once used its apples in a compote that I paired with a moist gingerbread cake for a Thanksgiving dessert idea. You can also find Melick's at Chatham, New Providence and several more markets.

For a lower-maintenance apple dessert perfect for friends who are vegans or those who have the willpower to "be good" during the holidays, serve a refreshing green apple sorbet, which is made by juicing the apples, adding a bit of sugar and water and freezing with an ice cream maker.

Whenever I've overdone it and bought too many apples, I make baked apples. Peel and core the fruit, nestle them in a baking dish and top each with a dollop of butter, sugar, lemon juice and warming spices such as ground ginger, cloves, nutmeg and cinnamon. Add dried cranberries, raisins, dates or chopped nuts if you have them. Bake until they are tender. Your problem of too many apples is solved as these disappear quickly.

Apples should not be parked in the dessert category. There are plenty of savory ways to use them. I like to update the American classic Waldorf salad by adding a pinch of curry powder. I prefer to use equal parts mayonnaise and yogurt in the dressing for extra creaminess and tang.

Slip thinly sliced apples into the center of grilled cheese sandwiches made with multigrain bread and sharp cheddar. These were a hit with the

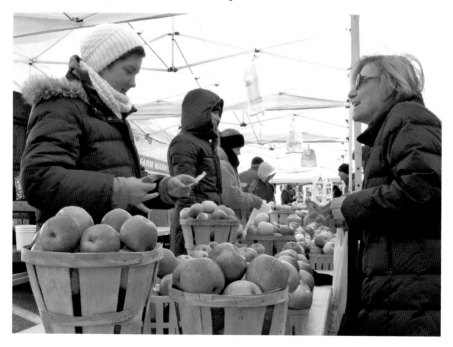

Customers stocked up on late-season apples at the Collingswood Farmers' Market.

kids when I did a cooking demonstration on getting children to eat more fruits and vegetables for the New Brunswick Parent Teacher Association. Afterward, the kids raced up to my table to help themselves to apples to take home with them.

A favorite and unexpected way to use apples is Lidia Bastianich's recipe for Spaghetti in Tomato-Apple sauce, which is in her book, *Lidia Cooks from the Heart of Italy*. She adds a pound of shredded apple to an otherwise simple marinara sauce.

Ed Kesler of Tree-licious Orchards in Port Murray sells an impressive array of apples at the Montgomery Township, Montclair, Riverdale and South Orange Farmers' Markets. The eighty-one-year-old orchardist is as spry as a spring sapling and still has a twang in his voice from growing up in Virginia. He favors the Stayman Winesap variety for its balanced flavor that is not too tart. It is also the orchard's best-selling apple. Visit its stand often to taste and learn the history of the Black Twig, Cox Orange Pippen, Opalescent and dozens more of its apples.

Terhune Orchards usually has thirty varieties available throughout the season at the Princeton, Trenton and West Windsor Farmers' Markets. I can't resist its Honeycrisp, Cortland and Macoun apples when I stop by.

Apples are stored best in cool, humid conditions. They can last up to two months in the fridge.

BROCCOLI

I write about vegetables with such love that I am sure I've led you to believe I love them all equally. I have a secret, though. I am not on Team Broccoli. It is so often used as an afterthought to "put something green" on the plate. Those steamed florets you push out of the way in your Chinese takeout container do more harm than good for getting people to love eating vegetables. That being said, I do have some favorite recipes that treat the sturdy stalks and compact florets with respect and creativity.

My all-time favorite broccoli recipe comes from chef Craig Koketsu. In 2008, while flipping through *New York* magazine, the simply dubbed "Broccoli with Cheetos" recipe caught my eye and changed the way I ate broccoli forever. Blanched broccoli is sautéed and set to swim on a sea of a rich sauce made with aged Gouda, a cow's milk cheese. The butterscotch notes from the cheese are complex and decadent. The high-low dichotomy

of combining an expensive, aged cheese with a topping of a crunchy snack food amuses me to no end. I saw several bags of Cheetos in my nephew's Halloween haul, and the rest was history. When I strained the sauce, I couldn't bear to discard those yummy cheesy solids, so I used them as a bagel schmear the next morning.

After making this, you'll have stalks left over. Don't just throw them out. Shred them in the food processor and make a nice crunchy slaw.

Broccoli pesto is an innovative way to turn broccoli into a spread. Boil the broccoli for four to five minutes until soft and then puree with lemon, garlic, olive oil and Parmesan. If your CSA box is bursting with broccoli, make extra pesto and freeze it. Swirl it into pasta or use it for an omelet filling.

Deb Perlman from the Smitten Kitchen has a genius recipe for broccoli Parmesan fritters that not only utilizes leftover steamed broccoli but also meets the criteria as an interesting green vegetable option for Thanksgiving and a fried food for Hanukkah. She mashes it with some flour, a beaten egg and a bit of cheese and fries them up to golden goodness. They freeze well and can be reheated in the oven.

Choose bright-green broccoli with firm stalks and compact heads. Store in the fridge where air can move around it. Storing in a sealed plastic bag is not advised because of humidity buildup.

BUTTERNUT SQUASH

We welcome fall with thoughts of leaves turning blazing orange and red and the desire to eat food in those autumnal colors. I love butternut's cheerful orange flesh so much, I teach a One Ingredient, Five Ways class taking this winter squash through a five-course meal. It really is that versatile.

Butternut happily stars in a meal's main event. Feeling cheesy? I add pureed squash to a sharp cheddar and Gruyere cheese sauce for my butternut squash macaroni and cheese. Top it with a crunchy layer of buttery Panko breadcrumbs and fragrant rosemary for a dinner you'll keep in heavy rotation all through fall. Switch it up with rigatoni instead of elbows and add sautéed greens, bacon and caramelized onions for a version to impress company. You just may get a standing ovation.

For a lighter pasta option, I toss chunks of roasted squash, arugula, lemon zest and a bit of Parmesan with fettuccine or penne. Roasting butternut squash before using it in soups or stews will enhance its sweetness. Peel the

entire squash and cut between the bulb and neck of the squash to make breaking it down more manageable. Now you can get evenly cut slices or cubes from the neck of the squash. Remove the seeds and reserve. Cut the flesh from around the seed cavity in half-rounds. Roast in an oven at 375 degrees with a small amount of oil, salt and pepper for twenty-five to thirty-five minutes.

If you are in a hurry, just slice down the middle and roast cut side up. When tender, remove the seeds and drizzle the squash with maple syrup and chopped pecans for a great side dish. It also makes a fine fall crostini when spread on toast with ricotta cheese.

To make a soup, sauté other ingredients; add roasted squash and chicken or vegetable stock; and simmer. I often make a rich, creamy, dairy-free soup with ginger and unsweetened coconut milk. Puree in a blender, being careful when you are working with the hot liquid. Get creative with your flavoring additions. Because butternut is sweet, try adding some heat with Sriracha or chipotle peppers.

Rinse the seeds and remove fibrous strands. Pat dry and dust with salt and chili powder, cumin or pumpkin pie spice and toast in the oven. Use these crunchy bits as a garnish for salads, tacos or soup.

Dessert ideas abound. Substitute pureed butternut in pumpkin pie recipes. Partnered with apples, pears and dried fruits, it can make a tasty pie or galette filling. Or perhaps slip some puree into brownies or chocolate cake.

Butternut squash can be stored at room temperature on the counter for about two weeks or in a cool, dry, dark location for two to three months. Try not to allow them to rest against a hard surface or other squash as soft spots may develop. Swaddle them with a crumpled newspaper or paper bag.

CAULIFLOWER

When the air gets crisp, I begin to fantasize about snow. Cauliflower's pale hue and crunch are harbingers of cozy evenings inside as snow falls and ice crackles outside. Keep the snowy theme going and smother a whole head with a cheesy Mornay sauce for a decadent side, or take it one step further and pile the mixture into a casserole dish and bake *au gratin* with a browned top and creamy interior.

I am addicted to roasted cauliflower. Cut the head into one-inch-thick slabs. Season them with caraway or fennel seeds, kosher salt and olive oil.

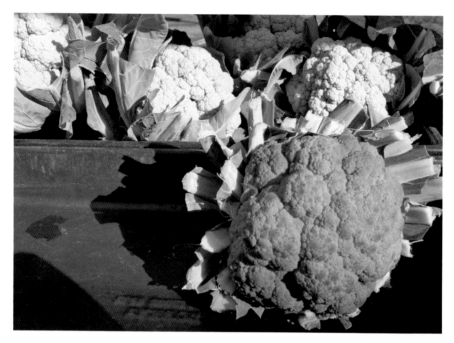

Purple cauliflower.

Roast in an oven at 375 degrees until they are tender and crisp around the edges. This method cooks the core as well as the florets, delivering more morsels to savor. If I don't eat all of it straight from the pan, I'll toss it with roasted carrots, a handful of chopped fresh herbs, mixed greens and a lemon dressing for a hearty lunch.

Cauliflower has a neutral flavor that pairs well with so many other ingredients. The Moosewood Collective in Ithaca, New York, has been working its magic with vegetables for more than forty years. Its cauliflower *agro dolce* lends the sweet and sour flavors of raisins, tomatoes and a splash of red wine vinegar to perfectly complement the firm florets.

Anchovies, olives and capers make a briny backdrop for florets browned in a hot pan. Toss your favorite pasta with cauliflower, crispy pancetta, peas and breadcrumbs for a quick weeknight dinner. I always keep a few slices of pancetta and a bag of peas in the freezer at the ready.

Indian cuisine also is a fast friend to cauliflower. *Aloo Gobi* is a perfect celebration of fall, combining potatoes, cauliflower and a heady blend of warming spices. *Gobi pakoras* are crispy fritters made with boiled florets that are dipped in a chickpea flour batter and fried. Traditionally served during

monsoon season in India, they are a perfect snack or starter on a blustery day here in New Jersey, too.

While shopping for cauliflower, look for firm heads with fresh leaves attached. Purple and golden varieties can be found at your farmers' market. They make stunning additions to a crudités platter. To keep the white variety pure as the driven snow, add a squeeze of lemon juice to the salted water before you use, blanch or steam it.

CELERY

I write in a room I've painted a color called "dark celery." Surrounded by these walls, you could say I practice the dark art of vegetable worship. I don't need a crystal ball to tell you that the often overlooked celery is on the rise.

A few years ago, I ate one of the best salads I've ever had at Ava Gene's in Portland, Oregon. Luckily, the recipe was featured in *Bon Appétit* magazine, so I don't have to organize a trip to the West Coast when I want to eat it. Crisp celery stalks cut on the bias are combined with sweet dried dates, salty Parmesan and crunchy roasted almonds. This salad is such a winner that I've served it to vegetable-phobic holiday guests and even they liked it.

This salad uses the celery leaves, which for so long we have been trained to lop off (along with the base) and discard. Stop doing that. Fancy restaurant chefs use celery leaves to make a salad or a garnish.

If you haven't used the leaves, pop them and the root end into a bag in the freezer with other goodies like carrot peels and parsley stems to use in your next batch of homemade vegetable or chicken stock.

Celery is an essential component of *mirepoix*, the trio of onion, carrot and celery that serves as base of almost every soup or stock.

Celery and Buffalo chicken go hand in hand. When I rode as a guest muncher on the *Star-Ledger*'s Munchmobile looking for the best pizza slices in the state, I fessed up to fancying a barbecue Buffalo chicken pizza. Pizza purist and head muncher Peter Genovese scoffed at me. That's fine. I'll happily eat this Buffalo pizza topped with diced celery and bleu cheese solo or with anyone else who shares my fancy.

On a visit to the West Windsor Community Farmers' Market, I paused in front of a modest display of celery at Great Road Farm's booth. With dark, strong stems and large leaves, it demanded my attention. I gave this vegetable its due with Marcella Hazan's recipe for braised celery with

pancetta and tomatoes. Braising celery is a terrific technique to deepen its flavor and soften it. Cooking it down with end-of-the-season tomatoes is a real treat. My father-in-law lays a bed of it down underneath pork roasts and chickens. They are so flavorful after soaking up those juices.

Look at celery for new possibilities—even if you decide to just go old school and make "ants on a log" as an after-school snack.

Celery tends to get limp if it languishes too long in the crisper. Combat that by wrapping it in a few paper towels and then aluminum foil instead of plastic. Unwrap, snap off the stalks you need and rewrap.

CRANBERRIES

With the holiday season fast approaching, cranberries are a festive addition to our menus. There is a great satisfaction in watching this hard little fruit relax, pop and release its flavor while cooking. It reminds me that the holiday season is about taking time to relax, too.

When I was at A Better World Café, we would turn fifty pounds of fresh cranberries into cranberry ginger chutney during the holiday season. We piled it on turkey sandwiches and sold it at special seasonal appearances at the Highland Park Farmers' Market. At home, two or three pounds of fruit makes a much more manageable batch. Package it in half-pint jars for edible gift-giving. Chutney will last up to two months refrigerated.

Take advantage of any unseasonably warm weather and fire up the grill. Make cranberry barbecue sauce to brush on any meat of your choice. Simply add some fresh berries to your tomato-based barbecue sauce until they break apart. It's great on tofu and grilled vegetables, too.

I like to make a cranberry vinaigrette at this time of year. Fresh cranberries pureed with mustard, oil and red wine vinegar result in a scarlet red dressing that looks gorgeous tossed with hearts of romaine or sturdy kale. Add a sprinkling of feta or blue cheese and a handful of toasted walnuts for a great seasonal salad.

New Jersey is the third-largest producer of cranberries in the country, which makes us very creative with them. The website Piney Power has a section dedicated to the "Magnificent Cranberry" with a slew of recipes, including one for cranberry slaw that pairs cabbage, grapes and cranberries in a creamy dressing.

Cranberries pair well with other fresh fruits such as apples, pears, grapes, pomegranate and oranges. Dried apricots and raisins play well together,

too. In baked goods, they work well with almonds, pistachios, chocolate and ginger. Not just a complement for turkey, cranberries can be served with salmon, shrimp, pork and lamb.

Look for firm, red cranberries at area markets. Heirloom varieties grown by Paradise Hill Farm in Vincentown can be found at several winter markets. Chickadee Creek Farm usually has some at its stands.

Store fresh cranberries in the refrigerator for up to two months. Frozen, they will last for one year.

Kale

National Kale Day is celebrated on the first Wednesday of October. You can usually spot me running down Main Street waving the leaves over my head dancing a jig. You may not believe that, but you can bank on my love for eating this versatile leafy green.

Kale actually becomes sweeter as the weather becomes cooler. Chilly nights will help the plants and make them perfect for eating a big bowl of kale and white bean soup. A hunk of crusty bread on the side is all you need.

When I was developing the menu for A Better World Café, I intended to have the offerings change daily according to produce availability. At our first tasting event, we served a vibrant mélange of ribbons of kale, shredded carrots, cabbages, scallions, brown rice, baked tofu, citrus sesame dressing and soy-roasted almonds. We named it the Better World Salad. The aptly named item became the only item we served every day.

Another salad I love to make in autumn showcases thinly sliced red apples, sturdy kale, sunflower seeds, Sriracha-laced dressing and roasted seaweed sheets that I cut into one-inch squares and add right before eating. This salad has crunch, sweetness, some heat and salt. Yum.

Baker Jackie Mazza is always adding local produce to her Knead Baked Goods line. When she is at the Hoboken Downtown Farmers' Market, she loves to buy kale from fellow vendors Union Hill Farms from Denville and Starbrite Organic Farm from Andover. The kale is often a topping for her focaccia breads.

Go ahead and play with your kale at the dinner table. Add some to a potato gratin with blue cheese and chives. A creamy risotto with bacon, kale and mushrooms will take a half hour to make and will disappear in less time.

Jackie Mazza uses kale in Knead Baked Goods focaccia breads.

If you usually cook up a mess of collards, kale makes a fine partner and adds a slightly different color and texture. First cook the collards until they are tender and then add the kale, which cooks faster. If you like, other greens like Swiss chard or spinach can be thrown in just before finishing. Be sure to use plenty of garlic and a dash of vinegar. Black-eyed peas and rice with these on the side makes a fine meal. If you'd like more protein, add some oven-baked chicken breasts, skewered shrimp or steak.

If your family isn't quite ready to eat more kale, perhaps they will drink it. Green smoothies combine leafy greens such as kale with banana, cucumber, apple and coconut water for a hydrating and nutritious between meal snack or quick breakfast.

Try making kale chips for snacking. Rinse and pat dry a bunch of kale. Tear the ribs off and discard. Rip the leaves into bite-sized pieces and massage with oil and kosher salt. Sprinkle on your choice of seasonings. Nutritional yeast or Parmesan cheeses are favorites at my house. Soy, ginger and cayenne are other go-to flavors. Put on a baking sheet for fifteen to twenty minutes in an oven at 375 degrees. Keep an eye on them, stirring a few times. They will shrink considerably and get crispy. Store them in an airtight container.

In the event you have too much kale, freezing is always an option. Keep it simple by blanching and shocking it and then whizzing up a kale pesto or sautéing before freezing in small containers. Simply defrost either and toss with cooked pasta or other recipes as needed.

Store kale in a plastic bag in the fridge and wash thoroughly in cool water before use.

Pears

For me, the pear is the most excellent fruit. You have a bit of a courtship with it. First you lock eyes at the market, decide to go home together and then you get to know each other for a few days as the pear slowly softens up at the neck and finally invites you to sink your teeth into its juicy flesh.

If you follow me on Instagram, you know I am obsessed with growing pears in my garden. I anxiously document their growing progress. But there is never enough. I am always on the lookout to supplement my supply.

My absolute favorite technique for cooking pears is poaching. They have a *wow* factor and are tender; best of all, they can be chilled and used several different ways. For the most dramatic effect, use red wine as the poaching liquid. White wine will show off the pears' natural beauty better. If you would rather not poach in alcohol, try *Top Chef* Season 2 contestant Sam Talbot's herb-infused liquid with lavender, mint, hibiscus flowers and chamomile tea swimming among the pears in the pan.

Use firm pears for poaching. For whole pears, I will use an apple corer to carefully remove the seeds from the bottom end. The fruit will cook faster if cut in half. A melon baller comes in handy to scoop out the seeds. Serve poached pears as part of a dessert course or a salad.

The gentle sweetness of pears is often partnered with blue cheese. Roquefort, Gorgonzola or Stilton can all be crumbled and tossed with greens, sliced pears and walnuts for a salad. Add sliced grilled chicken to make it an entrée. A quick blitz in the blender makes a creamy Roquefort dressing for dipping.

Tucking fruit into grilled cheese is one of my favorite dinner options. Opt for a cheese that has a good melt factor, such as Gruyere. Add sliced ham and a handful of arugula to make a killer melt.

If you are into canning, you can really make some wonderful goodies to savor through the winter. At a cooking demonstration at Kings Cooking

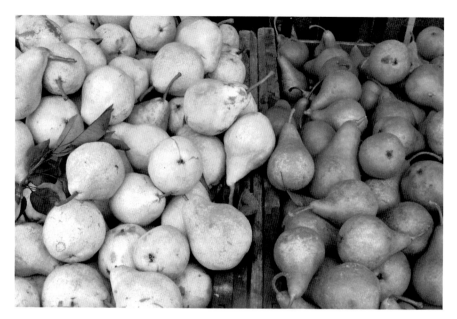

Pears.

Studio in Short Hills, I watched canning expert Marisa McClellan make pear vanilla jam. Emboldened by the lesson, I've successfully made a pear caramel sauce and chocolate pear jam from her book, *Preserving by the Pint*.

My mother loved it when I made pear and frangipane tarts for a Thanksgiving dessert. They pair well with ginger, cinnamon and star anise. Swirl some into a rice pudding or chocolate cake batter.

Pears ripen at room temperature after being picked. Don't plan on buying pears at the market and using them the same day. Set them on the counter and check daily by pressing softly on the neck. Once it yields to the touch, it is ripe. Refrigerate when ripe.

Pumpkins

Let's talk about the big pumpkin in the room. You always buy one to display for Halloween, and as it sits on the porch, it looks a bit more forlorn as each day goes by. If your pumpkin could talk, it might be whining, "When are they going to cook me?" A pumpkin is more than a decoration, and it's a terrible thing to waste.

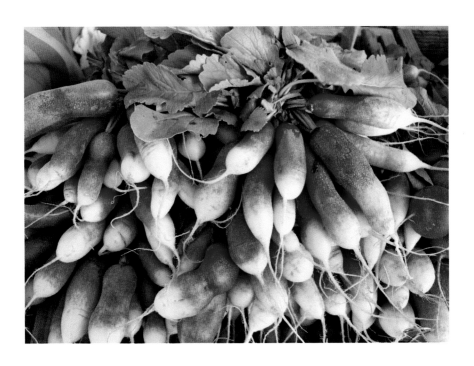

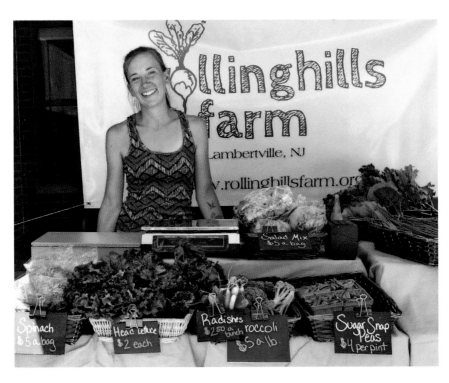

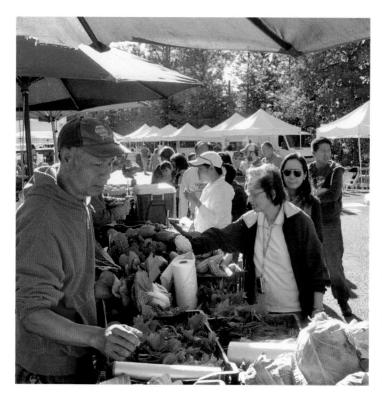

Shoppers at Chia-Sin Farm's stand at West Windsor Community Farmers' Market. *Chris Cirkus.*

Multicolored tomatoes and basil are ready to be roasted and frozen for winter use.

Red, green and Napa cabbages.

peanuts make these salads texturally satisfying and super-flavorful. Andrea Nguyen, author of *Into the Vietnamese Kitchen*, puts her own spin on this classic with a red cabbage, fennel and cashew salad that her family serves at Thanksgiving.

Kimchi is one of those "love it or hate it" condiments. I fall firmly in the "love it" camp. Koreans use the ancient technique of lacto-fermentation to create its salty, spicy bite. You can easily do it at home, too. The process for making kimchi takes a few easy steps: chopping, soaking, rinsing and massaging cabbage with salt and then, the hardest step, waiting a few days until it is ready to eat. Emily Ho's recipe at the website The Kitchn is a good place to start. Once you have the basic recipe down, you can experiment by adjusting the seasonings and heat level that comes from *gochugaru*, Korean red pepper flakes.

Not sure if you'll like it? Give it a try at the Cinnamon Snail, an award-winning vegan food truck that sets up shop at the Red Bank Farmers' Market on Sundays. Go for its Korean barbecue *seitan* sandwich or the *gouchujang* burger deluxe. Be sure to snag one of its yummy pastries, too.

My husband and I both enjoy braised red cabbage and apples and like it best served with a loin of pork. Add a little sugar and red wine vinegar for a sweet and sour vibe.

Our nephews love my coleslaw. I don't dare tell them how easy it is to make. I shred a head of green cabbage and a few carrots in the food processor. After transferring to a bowl, I sprinkle the veggies with a little kosher salt to draw out some moisture. A few minutes later, I stir in some sugar, celery seed, white balsamic vinegar, black pepper, a squeeze of mustard and mayonnaise. The flavor benefits from having a few hours in the fridge to chill before serving.

Heads of cabbage can be stored in the fridge for three weeks up to two months. If you only use a half or quarter of a head, cover the cut side loosely with plastic wrap. The next time you use it, trim the cut side to reveal nice fresh layers.

CARROTS

The simple act of grating a carrot in winter is so satisfying to me. In a quiet house, I concentrate on the sound, the color, the smell and the taste. I am reminded of the documentary *How to Cook Your Life*, which follows Zen master and cookbook author Edward Espe Brown at the Tassajara Zen Mountain Center in California.

In the film, Brown says, "When you wash the rice, wash the rice. When you cut the carrots, cut the carrots. When you stir the soup, stir the soup." I

think of that quote often while cooking. It is a reminder to slow down, focus on the task at hand and, most importantly, find joy in your work.

At the Slow Food Central New Jersey winter markets held at the D&R Greenway Land Trust in Princeton, I always linger near the display for Chickadee Creek Farm from Pennington. Farmer Jess Niederer rewards my rapt admiration by handing me one of her carrots still crisp and cool after coming straight from the farm. What a transcendent moment to taste in one bite all of its best qualities and to imagine its potential. Other shoppers were excited to stock up on them, too. In the parking lot, you could see them hurrying back to their cars inspired to cook, hugging clear bags of carrots to their chests.

After overeating during the holidays, I try to spend a week in January or February doing a winter cleanse with holistic health counselor Csilla Bischoff. Her carrot ginger soup satisfies my craving for sweets and is a snap to make. She purees simmered onion, carrots and fresh ginger, which Chickadee

Carrots grown by Chickadee Creek Farm in Pennington at a Slow Food Central New Jersey winter market at the D&R Greenway Land Trust, Princeton.

Creek Farm also grows. Mix the base recipe up by adding different spices like *za'atar*, a Middle Eastern mix of sumac, sesame, thyme, oregano and marjoram. For a bit of extra sweetness, try a dollop of wildflower honey from Birds and Bees Farm in Columbus or Tassot Apiaries in Milford.

The shredded carrot and raisin salad found on salad bars everywhere needs an update. Julie Sahni's south Indian carrot salad uses curry leaves, mustard seeds, lime juice and cilantro to bring each bite a burst of flavor and texture. For a tropical twist, cook sliced fresh pineapple in a grill pan and then chop before adding to your salad. Garnish with toasted coconut. A splash of rice wine vinegar or lemon juice will offset the sweetness.

Braising is a wonderful technique to render carrots tender but keep them whole. They are slowly cooked in liquid that will eventually evaporate until the carrots are slightly caramelized. These make an elegant side for a Sunday pot roast, short ribs or lamb shanks. Do look for a bunch of rainbow carrots in hues of yellow, orange and purple for the most striking presentation.

One of my favorite parts of working for Elijah's Promise was helping critique the practical portion of the midterm exam at Promise Culinary School. One student, Dimitri, made a vegetarian entrée I can't forget. He presented soy-glazed *seitan*, asparagus and a carrot puree that was light and fluffy. He boiled the carrots and blended them with vegetable stock instead of cream. He chose to leave little bits of carrot in the puree, instead of making it completely smooth, which I found texturally exciting.

Adding cardamom to carrot cake brings an exotic flair and floral notes to one of my favorite desserts. So good that the fluffy cream cheese frosting is optional.

Purchase carrots that are firm and crisp. If greens are attached, they should be fresh and green. Refrigerate for up to two weeks.

ENDIVE

I am obsessed with a certain salad. But not just any salad. The Three Trees Salad at Porta in Asbury Park has actually kept me up at night, plotting when I will get to eat it again. I have attempted to re-create its perfection in my kitchen at home. This crunchy flavor fest of pale endive, ravishing radicchio, arugula, crunchy bites of almonds and crisped prosciutto tossed in a luscious pear, shallot and rosemary vinaigrette is my dream salad.

Unfortunately, they are on to me over there. When I begged for the recipe to include in this book, they generously offered their Cavolo Nero salad instead. Well played, Porta. If that was my recipe, I would keep it secret, too.

Winter salads benefit from the crisp textured leaves and slightly bitter note of endive. Celebrate citrus season with a clementine, black olive and endive salad. Playing with briny and sweet flavors, this salad packs in the flavor.

Build a salad with an eye for color. Slivers of red onion, deep green ribbons of kale, strands of micro greens, shaved beets, blood orange segments and pomegranate seeds all pop when combined with demure endive leaves in the salad bowl. Add some crunch with walnuts, pepitas or sunflower seeds.

The endive is one of the culinary world's most unusual, useful plants. Part of the chicory family, it begins its life lush and green in the fields. The tops are harvested, and the roots are brought inside for cold storage.

Lore tells us that a Belgian farmer harvested his crop in the 1800s and was surprised to see that the roots had sprouted and grown new leaves in the dark. These Belgian endives were sent to the market in Paris, where they were deemed tres chic. A winter's treasure was born.

The easiest, most elegant way to use them is in hors d'oeuvres. Separate and trim the leaves. Arrange on a platter and fill with whatever your heart desires. I like to use a pastry bag to pipe on a creamy filling made with caramelized onions and spinach. A protein-rich vegan option would be edamame with miso dressing. If you are craving a respite from the snow banks outside, topping endive with mango and shrimp will transport you to the tropics momentarily.

The leaves are sturdy enough for dipping and are the perfect gluten-free alternative for crackers. Bring some hunks of cheese and endive with you to your ski chalet and enjoy six-cheese fondue with your friends after coming back in off the slopes. Serve with sliced apples and pears and a baguette. If you've never made fondue before, this is the perfect excuse.

The endive doesn't have to be enjoyed raw. Try them grilled with pistachios, dried cherries and feta or braised with pancetta and white wine. Pick up some local mushrooms at one of the indoor winter farmers' markets and put together a stir-fry with shiitakes and endives. Forbidden black rice will look stunning alongside of the dish.

Purchase endives with smooth, firm leaves and closed ends. Store in the crisper drawer of the refrigerator up to one week.

Garlic

One has to do little more than begin to sauté garlic to have someone passing through the kitchen exclaiming, "It sure smells good in here." With its antibacterial and antifungal properties, it is especially welcome in winter to ward off the sniffles. It's also the perfect time to revel in a little garlic breath since, most likely, you will be cooped up in the house solo or with someone who isn't afraid to give you a smooch after getting your garlic on.

Peeling garlic takes a few moments, and your fingers often get a little sticky and scented with its fragrance. That is no excuse for buying chopped garlic in a jar, though. Stop doing that!

Slow poaching whole cloves or slices of garlic makes the house smell amazing. In a small sauté pan, scatter a single layer of garlic and almost cover with olive oil. Cook over a low flame until the garlic is tender. I like to use a few of the poached cloves to enhance mayo for a sandwich spread. Add some to soups, tomato sauce or Alfredo sauce to boost flavor. The oil can be used to add garlic flavor when you don't want chunks of garlic present in a dish or you are too rushed to chop. Store garlic and oil separately in the fridge for up to a week.

You may also roast a whole head of garlic. Simply cut off the top of the head so the cloves are exposed, place on a piece of aluminum foil and drizzle with oil, kosher salt and pepper. Wrap up the packet and pop in the oven at 350 degrees until tender. When cool, the cloves will easily squeeze out of the skins. Add them to hummus. Mash and add to cannellini beans and sundried tomatoes for a winter bruschetta topping. Mashed garlic potatoes will never disappoint.

A roasted chicken is one of the simplest suppers, yet it is so satisfying. Cook a bird with gusto and include forty cloves of garlic in the pan with lemon and herbs. It sounds like garlic overload, but this recipe is a classic for a reason. Be sure to keep all the yummy pan juices to make gravy.

Robert "Vito" DeVito took over as chef after I left A Better World Café. He knows comfort food is best when approached with a focus on simplicity. He often speaks of how his grandmother could make dinner from almost nothing. When he makes his spaghetti *aglio e olio*, it always sells out. Who doesn't like spaghetti dusted with Parmesan and parsley, enrobed in oil with a kiss of chili?

China grows the lion's share of garlic for the world. The United States produces a mere 2 percent of the world's supply, but it is readily available. You can feel good about stocking up on a local farmer's crop. Purchase garlic

Heads of garlic.

heads that feel firm. The skin should feel dry and papery. There should be no sign of green sprouting. Store at room temperature in a dark, dry location with good air circulation for up to two months.

LEEKS

On the darkest days of winter, when the wind is howling outside, I pay the weather no mind as I dip my spoon into a giant bowl of creamy leek and potato soup. It is even better topped with frizzled leeks, their tiny strands fried until crispy. They are pretty heavenly piled on top of a nice thick steak, too.

Our friends across the pond make better use of the leek than we do here in the States. With their mellow onion flavor, they have a place in all sorts of one-pot meals. Scottish cock-a-leekie soup—a chicken-based broth with bobbing bits of leeks, shredded chicken and carrot—is thickened with

barley. Some versions include prunes, which add a touch of sweetness to every spoonful. The Irish incorporate leeks into cheddar and beer soup. A big steaming bowl of either of these and a hunk of crusty bread make a wonderful winter supper.

Leek and goat cheese tarts can be made with pie crust or puff pastry as your base. It's a great way to use up little bits of cheese you have left in the fridge on Sunday morning. Keep some puff pastry sheets in the freezer for times like these. Add a custard base and bake in muffin tins or ramekins for individual portions or in a nine-inch tart pan for a larger party. Serve with a big salad.

It is amazing that even in the dead of winter, an entire meal can be sourced locally. One of the winter markets will have a vendor selling leeks, potatoes, dairy, bread and even the beef and chicken.

It takes a very sturdy crop to stand up to snow. Leeks are up to the challenge. Planted deep, they stand proud out in the field and are harvested as needed throughout the winter. Seeing their tops peeking out of my own snow-covered garden gives me solace that winter hasn't killed off all the greenery.

Many recipes call for using the white and light-green portions only. Don't discard the greens, though. If they aren't too tough, I will slice them into very small strips and then blanch them to retain their color and quickly sauté in clarified butter to soften them. Pile these beneath a fish filet or chicken breast. For better flavor but a less vibrant color, roast the thinly sliced leek until crispy on the edges. Those are terrific loaded inside a grilled cheese.

If the tops are just too tough or battered, toss them in a freezer bag with other scraps such as celery leaves and carrot peels until you are ready to make a batch of chicken or vegetable stock.

Leeks often take less time to cook than it does to properly clean them. I slice the leeks lengthwise until just above the root end. Fan them out under running water and then swish in a basin of cool water to ensure that all of the grit is removed. All of those tight layers can trap bits of earth inside.

Mushrooms

If you really commit to eating seasonally like I do, there is a point in winter where it begins to look a bit bleak out there. Don't despair. This is the perfect time to seek out produce grown indoors. Mushrooms are available year-round, but they become truly vital during winter.

King oyster, lemon oyster and shiitake mushrooms from Shibumi Farm.

At my family's holiday table, there are always stuffed mushrooms. We load them with lump crab meat, chopped parsley, a glug of Worcestershire sauce and just enough mayonnaise to hold the mixture together. I'm just as happy eating them cold at midnight standing in front of the fridge as I am passing them at the table.

When I was beginning to cook on my own as a kid, I turned to James Beard's recipe for pork chops with mushrooms and vermouth time and again. I put my own spin on the recipe for my very first "Gutsy Gourmet" column for the *Star-Ledger* in March 2012. I used *maitake, enoki* and beech mushrooms. Feel free to try your own combinations.

Princeton's Shibumi Farm always has numerous unusual varieties at the market. My friend Sandy claims to be addicted to their *maitake* (otherwise known as hen-of-the-wood) mushrooms and makes sure to score a little brown bag of them every week at the West Windsor Community Farmers' Market. Get hooked on some of their other offerings like shiitake, lion's mane, lemon oyster, beech, *champignon de Paris* and pioppino. Mushroom-centric dinners held at the Brothers Moon in Hopewell often feature Shibumi's fungi.

Stephanie Spock and John Squicciarino from Rolling Hills Farm in Lambertville show off their oyster mushroom kitchen garden kits.

Davidson's Exotic Mushrooms from Kennett Square, Pennsylvania, can be found at lots of markets around the state. Its portobello mushrooms are great for grilling. I'll often use Peter Berley's recipe for Asian noodles in broth with vegetables and tofu or steak to extract flavor from meaty portobello stems that would normally be discarded. The broth takes about twenty minutes to make. Snappy from the addition of rice wine vinegar, soy sauce and mirin, it feels like a tonic after weeks of overindulging. The beauty lies in Berley's flexitarian concept: make a vegetarian base and then add meat or vegetables as you choose.

A creamy bowl of mushroom soup is a favorite winter lunch. A Hungarian version enriches the soup with sour cream and a hint of spice from paprika and the freshness of chopped dill. Allow a handful of mushrooms to find their

way into risotto, a savory bread pudding or onto a homemade pizza. I insist that you sauté them first before topping the pie and sliding it into the oven.

If you are looking for a fun, new winter hobby, Rolling Hills Farm from Lambertville is selling oyster mushroom kitchen garden kits at its market stall. You can begin harvesting in about two weeks. Check it out at the Asbury Fresh Market in Asbury Park and at the Frenchtown Farmers' Market.

Condensation is not the mushroom's friend. Store them in a brown paper sack or open in the main section of the fridge. Be careful not to bog them down with water while cleaning. I usually give them a firm rub down with a damp cloth. If you feel compelled to rinse them in water, do it quickly and dry them thoroughly. Purchase them in small enough quantities that can be used within a week.

PARSNIPS

As you pass by tables piled high with produce, pause to consider the pale parsnip. Without a blush of color, it does not vie for your attention like its cheerful cousin, the carrot. Yet this creamy root vegetable makes up in taste for its bland looks. Its sweetness becomes even more pronounced after being in the field during frost.

I love adding parsnips to mashed potatoes. On a leisurely Sunday, it is so nice to have something like Zinfandel-braised short ribs merrily bubbling in the oven while you read the newspaper and tidy up the house in your pajamas. Pile the succulent beef and gravy on top of the mash. In the event you have leftovers, make shepherd's pie on Monday.

Roasting parsnips for about an hour in an oven at 350 degrees renders them tender and sweet. Cut them into coins or batons and roast alone or with other root vegetables and winter squash. Toss them with a handful of chopped fresh herbs. If you have a sunny window, keep little pots of rosemary, thyme, mint and parsley for moments like these. Once you have a tray of roasted parsnips, you can turn them into a main dish, like a roasted vegetable galette with olives and goat cheese, or a salad with hazelnuts and dried cranberries, both Jersey crops.

Parsnips can also be eaten raw. North African spiced carrot and parsnip salad tosses shredded raw roots with harissa, a spicy paste of peppers, pistachios, cilantro and lemon.

Storage is similar to carrots. They will keep for weeks in the crisper drawer. Avoid really big specimens, which have a woody texture.

POTATOES

I can eat my own weight in mashed potatoes. There can never be enough of them in our house. On New Year's Eve, we'll make a really decadent batch and serve them with a steamed lobster, roasted garlic butter and a salad. It's my version of down-home luxury. For a summer version, try catching some blue crabs to go with the spuds.

Barry Savoie actually calls himself "the Potato Guy." He spent years working full time as a nuclear power engineer at Oyster Creek while working his family's fourteen-acre farm in Williamstown part time. In 2014, he dedicated himself full time to Savoie Organic Farm. Potatoes are a passion for him. He grows ten varieties on two acres. The week before Thanksgiving, his booth at the Collingswood Farmers' Market was mobbed as customers snapped up five-pound bags of Adirondack All Blue, Kennebec and Cranberry Red potatoes to tide them over until next season.

If all you really crave is a French fry after contemplating your market find, you have to make pommes soufflés, the "real" French fry. These very thinly sliced potatoes are fried twice, the first time at a lower temperature of 280 to 320 degrees. Then they are fried a second time at 350 to 400 degrees. Use a spider or slotted spoon to flip them carefully. The potatoes

Potatoes from Savoie Organic Farm in Williamstown.

Farmer Barry Savoie.

will puff up and brown on all sides. Blot on paper towels and salt liberally. Try to get them to the table without burning your mouth on a sneaky bite of these crispy morsels.

A boiled potato can be a thing of beauty when accompanied by a shower of sea salt, freshly cracked black pepper and a dose of good butter. You might as well add some corned beef and cabbage to the menu plan, too.

Loaded baked potatoes are an old-school favorite. I still love to make a lunch of them. Top them with all sorts of goodness, like truffle oil, pesto or shards of clothbound cheddar.

You could seriously eat potatoes every day for a month and never get bored. For example, rotate these ten ideas three times per month: Samosas, chowders, latkes, creamy soups, knishes, gnocchi, hash browns, croquettes, salads and gratins. You get the point. And you'd better get two to three times more than you think you'll need when shopping.

Store potatoes in a cool, dry, dark place away from onions, which emit a gas that encourages potatoes to spoil quicker.

RUTABAGA

When Women Chefs & Restaurateurs awarded me an organic internship with Nora Pouillon the summer after I graduated culinary school, everything came into focus for me. After spending time with Nora in the kitchen at Washington, D.C.'s Restaurant Nora and visiting many of the farms she sources products from, she arranged a special invitation for me to briefly visit with chef Patrick O'Connell of the Inn at Little Washington in Washington, Virginia.

Gregorian chants played over the sound system in the spectacular kitchen as the cooks silently prepped the evening's meal. Listening to such ancient music while cooking really connects us to the culinary history of a food's past. Imagine a cook making a rutabaga soup in a cauldron in the scullery of a stone castle four thousand years ago and then fast-forward to today's more modern kitchen. Much has changed over time, but the beauty of a simple soup remains. O'Connell favors pairing rutabaga with other storage crops—apple, sweet potato, carrot and butternut squash—in a velvety soup that is sweetened with a bit of maple syrup.

As we enter the final days of winter, I'm always amazed that there are still locally sourced fruits and vegetables available at market. I feel such a surge of pride in New Jersey's farmers, who work so hard during the growing season. Thankfully, they always plan ahead and create a secret stash of hardy produce to get us through the winter.

As soon as it gets a tiny bit chilly, we greedily gobble up their carrots and apples. But have you tried the rutabaga? This funny-looking, partially purple root vegetable with the awkward name is most likely not the first item you rushed to snag at the indoor farmers' markets this winter. Let's remedy that.

Heavy and dense, choose just a few to bring home. Deep flavor lies in the golden flesh beneath the skin. Break out your cleaver or sharpest knife to chop them into manageable slices and then dice. Watch those fingers!

Rutabagas willingly hop into the soup pot. For a refined choice, there's the allure of smoky flavor in a smoked paprika rutabaga bisque. Simmer the rutabagas with aromatics and then puree before adding cream. They'll do great in your favorite chicken soup, too.

Anything prepared gratin-style is comforting. Use a mandoline to thinly slice rutabaga. Layer them with a creamy sauce in a casserole dish and bake into a golden, bubbly, blissed-out state. Put this on the table with Sunday's pot roast.

For a substantial winter breakfast, try poached eggs over a rutabaga hash with onions and crisp bacon. Breakfast for dinner is always fun once in a while, too. Add a generous dollop of horseradish to mashed rutabaga for an

excellent side. You guessed it: one of your friendly local farmers will have the horseradish you need.

Save room for dessert. Surprise your guests with a rutabaga pie. All of the spices in a pumpkin pie are folded into whipped rutabaga. Care for another slice, Dad?

Farmer Mark Canright from Comeback Farm successfully stumped one of his regular customers when he presented her with a rutabaga one December morning. Pleased with himself, he brandished one in his gloved hand and said, "This is the one vegetable that can still get bigger in December. Everything else just sits there, but these actually get bigger."

The next time you see this strange little root at the market, bring some home. Rutabagas are best stored in the refrigerator for up to three months.

Spinach

Desperate for seasonal greens, I try to have a small mountain of spinach on hand to turn into dinner delights. I give some a quick sauté with garlic and mushrooms before adding to a pot of simmering chicken stock made from the leftovers of a roasted organic chicken. Right before serving, I'll add some pastina to the bowl. I save a box of this tiny star-shaped pasta for this occasion.

Visit just about any of the Greek diners in New Jersey and you are bound to find *spanikopita* on the menu. Phyllo sheets brushed with melted butter are layered with a mixture of spinach cooked with onions and garlic. Plenty of feta cheese studs the filling. A wedge of this spinach pie makes a hefty serving. For smaller appetites, cut the phyllo into long strips, place a spoonful of the filling toward one end and fold the dough over and over into a triangle. Once baked, the pastry is incredibly crisp. Making *spanikopita* takes some patience. Don't take this on if you have to be somewhere soon. I like to get going and make two pans: one for dinner now and one to freeze. The triangles freeze well, too.

Invite friends over for an Indian buffet at home, with *palak paneer* at the center of the table. This creamy blend of spinach cooked with fiery chilies, cumin seeds and yogurt is dotted with chewy squares of paneer cheese. Add basmati rice for a fun feast.

You can certainly make yourself a big spinach salad for dinner, too. On weeknights, I like to set a piece of tamari and maple-glazed roasted salmon on top and make a spicy dressing.

Spinach is also a popular addition to smoothie drinks. Holistic health counselor Csilla Bischoff has a slew of recipes for sippers that incorporate greens. I particularly love her mango, banana and spinach smoothie. With lots of blueberries stashed in my freezer, I'll often use them in a smoothie, too, with a few handfuls of spinach thrown in.

Many farms grow spinach in high tunnels or under row covers. It should be easy to find at winter markets. Keep spinach dry until you are ready to use it. Store loosely packed in a gallon-sized storage bag in the fridge for three to five days.

Watermelon Radishes

On these cold winter days, any pop of color gets me excited. The Chinese red meat or watermelon radish is a slightly unusual crop that has been showing up with more frequency the last few seasons. These globe-shaped radishes are usually a bit larger than beets. The exterior ranges from white to lime green. Inside, its heart is fuchsia.

Steve Tomlinson of Great Road Farm in Skillman likes growing them a lot. "They are a beautiful vegetable that store well and brighten up a winter salad," he said. He and chef Josh Thomsen at Agricola in Princeton like them so much that the farm will store upward of three hundred pounds of them per season for use at the restaurant and to sell at market. Paired with the tender lettuces he grows in the high tunnel on the farm, a locally produced winter salad truly is within reach.

Try pairing them with cabbage, alfalfa sprouts and quinoa for a protein-rich vegan lunch. Add a Chinese element to your salad with toasted sesame oil dressing and a sprinkle of black sesame seeds to mimic the seeds in an actual watermelon. Playing with their color is key. How many other colors from the rainbow can you pair them with?

My favorite new idea for preparing them is watermelon radish chips. We've ridden the wave of kale chips into shore, and I predict that this colorful crunchy snack will be the next big thing—at least in my humble kitchen. I use a dehydrator to make all sorts of dried snacks, but you can also successfully dry them for several hours in an oven set to the lowest temperature possible.

Julienne some and top a Vietnamese *bahn mi* sandwich with the pink strands to lend a layer of crunch between the baguette and tender meat. Or make a slaw with them to top some Asian-fusion tacos.

These radishes don't need to be eaten raw. Sauté them quickly with Chinese chives and butter. Toss them into a stir-fry with any meat or tofu of your choice.

Tomlinson told me that he likes to make a quick pickle with them. He combines three cups of distilled white vinegar, one teaspoon of sugar, two tablespoons of kosher salt, one teaspoon of mustard seed and one teaspoon of coriander seeds in a bowl. Pour two cups of boiling hot water over the mixture until the sugar is dissolved. Set aside to cool. In a quart-sized canning jar, pack in one bunch of dill, one chopped onion, a cayenne pepper and three cloves of garlic. Next, pack sliced watermelon radishes into the jar until it is filled. Add the vinegar mixture. Seal and store in a refrigerator for up to one month. Every time you open the fridge and see the pretty pink pickles, you are bound to smile.

Part VII

Recipes

PASTA E PISELLI

Michael Fiorianti, executive chef at Satis Bistro
212 Washington Street, Jersey City
satisbistro.com

Yield: 8 to 10 servings

INGREDIENTS:

Mint and Basil Pistou
2 cups whole leaf mint
1 cup whole flat leaf parsley
1 cup whole leaf basil
zest of ½ lemon
extra virgin olive oil

English Pea Puree
1 large shallot, fine diced
2 garlic cloves, minced

1 pinch crushed red pepper
2 pounds fresh English peas, divided
2 mint sprigs

1 pound angel hair pasta
6 cloves garlic, sliced thin
parsley, chopped
pea tendrils or shoots, if available

DIRECTIONS:

1. Make pistou. Put a pot of water to boil and add kosher salt; once boiling, it should taste like sea water. Have another bowl of ice water prepared on the side.

2. Blanch leaves by dropping into the boiling water for about 20 to 30 seconds and then immediately into the ice water. Remove and squeeze out all the water from the leaves.

3. Place in blender with lemon zest, a splash of olive oil and one ice cube (this helps keep the color). While running, add enough oil slowly in a stream until a thin pesto consistency is reached.

4. Make puree. Sweat shallot and garlic lightly in olive oil. Add the red pepper flakes and stir; then add 1 pound of fresh peas, mint sprig and stir. Add just enough water to cover the peas. Bring to a boil and cook for about 1 to 2 minutes.

5. Remove the mint, season with salt and pepper and puree in blender until smooth. Add water if needed to thin out as you puree.

6. Cook pasta in salted boiling water as per package directions. While cooking, sauté sliced garlic to golden brown in olive oil. Add parsley and then second pound of peas, whole, and cook for 30 seconds. Add pasta once cooked.

7. Add a few spoons of the pistou to taste along with a ladle or two of pasta water. Finish with pea tendrils or shoots and check for salt and pepper.

8. Spread some pea puree on the bottom of your serving plate and serve pasta on top of that.

RHUBARB UPSIDE-DOWN CUPCAKES (GLUTEN FREE)

WildFlour Bakery Café
2691 Main Street, Lawrenceville
wildflour-bakerycafe.com

Yield: 12 servings

INGREDIENTS:

Rhubarb Compote
*2 tablespoons unsalted butter ***
½ cup brown sugar

¼ cup granulated sugar
½ pound rhubarb, trimmed and cut into ½-inch pieces

Batter
1 cup granulated sugar
2 large eggs
1¼ cups gluten-free flour blend**
¼ teaspoon salt

1½ teaspoon baking powder
½ teaspoon xanthan gum
½ cup milk
1 teaspoon pure vanilla extract
½ cup canola oil

DIRECTIONS:

1. Preheat oven to 350 degrees.
2. Grease muffin pans.
3. Make the rhubarb compote. Melt butter in a saucepan, add sugars and stir until dissolved. Add rhubarb.
4. Remove from heat and divide among cupcake forms.
5. Beat sugar and eggs in the large bowl of an electric mixer on medium speed for 1 minute.
6. In a separate bowl, combine flour blend, salt, baking powder and xanthan gum and whisk together.
7. Add flour mixture to batter with milk, vanilla extract and oil and continue mixing for 1 minute.
8. Pour batter on top of the rhubarb preparation to fill molds ⅔ of the way to the top.
9. Bake in the preheated oven for approximately 20 minutes.

*Coconut oil and coconut milk may be substituted for a dairy-free recipe.

**WildFlour uses a blend of brown rice, potato starch and tapioca flour. Make sure the blend you use does not contain xanthan gum. Most packaged gluten-free flour blends use guar gum or xanthan gum in the preparation, so if you use them, omit the xanthan gum in our recipe. You can buy WildFlour's blend at its bakery café or make your own blend with the following.

GLUTEN-FREE FLOUR BLEND
¾ cup brown rice flour
⅓ cup potato starch
2 tablespoons tapioca flour

VIETNAMESE-STYLE LEMONADE SHRUB AND A MINT JULEP COCKTAIL

Warren Bobrow, the "Cocktail Whisperer," author of Bitters and Shrub Syrup Cocktails, Whiskey Cocktails *and* Apothecary Cocktails.
cocktailwhisperer.com

I love Vietnamese lemonade, and just a touch of this salty, tart confection in a mint julep made with this gorgeous bottle of Barrell Whiskey: Batch #001 is going to set me on fire. Not actually on fire, but you know what I'm alluding to—I hope you do anyway…

—Warren Bobrow

For the Shrub

INGREDIENTS:

1 cup Vietnamese preserved lemon segments (Asian grocers carry this)
1 cup of Vietnamese palm sugar (also available at Asian markets)
1 cup apple cider vinegar (I use Bragg's; you should, too)

DIRECTIONS:

1. In a non-reactive bowl, combine the lemons and the palm sugar.
2. Cover with the sugar and some plastic wrap and let sit for three days in a cool place, stirring twice daily with a wooden spoon.
3. Add the vinegar and stir well; cover.
4. Let sit, stirring twice daily for another few days.
5. Strain and mash through a sieve, extracting as much lemon pulp as possible.

Use in just about any gin, vodka, rum, bourbon or Scotch cocktail you can dream up—or even as they did in the 1800s with just cool water or seltzer water for the original energy drink.

Vietnamese-Style Lemonade Mint Julep

INGREDIENTS:

fresh spearmint
½ ounce demerara sugar
crushed ice

2 ounces Barrell Whiskey: Batch #001
1 ounce Vietnamese lemonade shrub

DIRECTIONS:

1. Muddle your fresh spearmint with your demerara sugar until the oils come out.
2. Use a wooden spoon. If you use metal in a silver cup, all bad things will happen. You are using a sterling silver/copper cup, right? If not, all is not lost. Use a thick-sided glass that will frost up nicely. (Save your nickels and buy a julep cup, though—it's worth it.)
3. Add some ice and then some bourbon.
4. Add some shrub and so on, alternating until your glass is full of your drink.
5. Make a cone like a volcano shape on top of the drink with ice and drizzle some of the Vietnamese lemon shrub over the top.

Serve one to your friend before drinking your own.
You can garnish with fresh mint and lemon zest. That is nice.
Smile while you prepare it. The drink knows.

GARDEN STATE SEAFOOD PANZANELLA SALAD

Jim Weaver, Tre Piani
120 Rockingham Row, Princeton
trepiani.com

Yield: 2 servings

INGREDIENTS:

1 large baguette
½ cup large Jersey tomato, diced
½ cucumber, julienne or, preferably, cut on a mandoline to resemble spaghetti

¼ fennel bulb, julienne (reserve a few fronds for garnish)
2 garlic cloves, sliced
1 scallion, cut on the bias into thin slices (reserve the green top for garnish)

4 basil leaves, chiffonade, plus a few whole
 leaves for garnish

3 ounces monkfish

8 Little Neck clams

4 large sea scallops

3 ounces calamari

½ cup extra virgin olive oil

½ teaspoon sea salt

black pepper to taste

1 cup water

1 tablespoon lemon juice

DIRECTIONS:

For the bread:

1. Remove the crust from the bread and cut into ½-inch cubes.
2. Lightly toast the bread in an oven at 350 degrees and set aside. You will need about ½ cup of toasted bread cubes for the recipe. The rest of the bread can be used for an optional garnish if desired.

For the vegetables:

1. Cut the tomato into large dice. Julienne the cucumber and fennel.
2. Slice the garlic cloves.
3. Cut the scallions into small slices on the bias.
4. Chiffonade the basil.
5. Reserve some scallion tops and fennel fronds for garnish.
6. Keep all of this chilled until ready to use.

For the seafood:

1. Skin the monkfish and cut into bite-sized pieces.
2. Rinse the clams of any sand.
3. Peel the abductor muscle from the sides of the sea scallops.
4. Peel and clean the squid, and pull the tentacles and all that are attached from out of the tube. Cut the tentacles off just above from where they start and discard the beak and eyes. Also remove the tough, clear membrane from within the tube and discard.
5. Slice the squid into ¼-inch rings.
6. Keep all of the seafood well-chilled until ready to prepare.
7. Heat a large sauté pan and add the olive oil.
8. Season the scallops and monkfish with salt and pepper and sear them until browned on the outside; remove from the oil and reserve on a plate on the side.
9. Add the garlic and let brown slightly; add the calamari and give a quick toss.
10. Next add the clams and the water, seasoning lightly with salt and pepper. Cover until the clams begin to open and then return the scallops and monkfish to the pan.

11. Cook covered until all the clams open or about 1 minute. You may have to add more water if the clams do not open—you just want to make sure that you have about ½ cup of liquid left when the dish is finished.

To assemble:
1. Put the cut vegetables into a large bowl with the basil and lemon juice and season with salt and pepper.
2. Add the bread cubes and toss with the vegetables.
3. Just before serving, toss in the hot seafood and half of the cooking liquid.
4. Portion onto plates, garnish with the scallion sprigs, basil leaves and fennel fronds and pour the remaining seafood broth around each plate. Serve immediately.

Peach Galette

Rose Robson, Robson's Farm
Wrightstown
robsonsfarm.com

INGREDIENTS:
2 cups peaches, peeled and sliced
1 tablespoon flour
¾ cup ricotta cheese
1 tablespoon sugar
1 pie crust (homemade or store-bought)
2 tablespoons butter
3 tablespoons agave
1 egg

DIRECTIONS:
1. After peeling the peaches, combine with 1 tablespoon of flour.
2. In a separate bowl, mix ricotta and sugar.
3. Lay out the pie crust on a baking sheet lined with parchment. Spread ricotta mixture in an even layer on pie crust, leaving 1 to 2 inches of space along the outside edge.
4. Add the peaches on top of the ricotta. Fold the outer edge of the dough up and over to slightly overlap the filling.

5. Melt the butter and agave and pour over top of the peaches.
6. Whisk the egg and brush the edges of the galette with the egg wash.
7. Place in the oven for 30 to 35 minutes at 350 degrees.

Summer Vegetable Frittata

Josh Bernstein, executive chef at Spuntino's Wine Bar and Italian Tapas
70 Kingsland Road, Clifton
spuntinowinebar.com

Yield: 4 to 6 servings

INGREDIENTS:
¼ cup clarified butter
¼ cup Spanish onion, small diced
¼ cup green bell pepper, small diced
¼ cup zucchini, small diced
½ bunch rainbow Swiss chard, cleaned and chopped
8 cherry tomatoes, quartered
12 cage-free eggs, beaten
½ bunch basil, chopped
sea salt and ground black pepper to taste

DIRECTIONS:
1. Heat a 14-inch nonstick sauté pan over medium-high heat. Add the clarified butter.
2. After about 30 seconds, add the onions, peppers, zucchini, Swiss chard and tomatoes. Cook for 2 to 3 minutes. Season to taste with the sea salt and ground black pepper. Mix in the eggs and stir with a rubber spatula.
3. Smooth the mixture out and cook in an oven set at 400 degrees for 5 to 7 minutes. The eggs should be fully set and slightly browned on top.
4. Slide the frittata out of the pan onto a round plate. Cut into 8 to 10 wedges.
5. Garnish the top with chopped basil.

Pear Tart with Balsamic Brown Butter Onions and Local Sheep's Milk Cheese

Andrea Carbine, owner of A Toute Heure and 100 Steps Supper Club & Raw Bar
A Toute Heure, 232 Centennial Avenue, Cranford
atouteheure.com
localrootscranford.com

Yield: 4 servings

INGREDIENTS:

Pears
4 firm-fleshed pears (preferably Bosc from Terhune Orchards, Princeton)
1 tablespoon honey (preferably Tassot Apiaries spring honey from Princeton)
4 tablespoons unsalted butter, room temperature
kosher salt

Balsamic Brown Butter Onions
½ cup olive oil (not extra virgin olive oil, but you can also use a grapeseed or unflavored cooking oil)
6 tablespoons unsalted butter, room temperature
1 yellow onion, cleaned, topped and sliced into half-moon slices
¼ cup balsamic vinegar (not super-aged)

Puff Pastry
1 sheet of puff pastry cut in 6-inch-long by 4-inch-wide tart shells (each sheet should make at least 4 shells, with some left over)
1 egg (for egg wash)

Cheese
1 cup grated cheese (Smokey Shepherd from Valley Shepherd Creamery in Long Valley)
2+ shavings per tart to finish

DIRECTIONS:
1. Preheat oven to 350 degrees.
2. Clean and scrub pears, cut in half and core out centers and top and bottom stem spots.
3. Slice pears lengthwise from top stem to base approximately ¼-inch thick—this should give you 3 or more slices per half of pear (leave the skin on).
4. On a parchment-lined sheet tray, spread out pear slices so they don't overlap.

5. Rub each pear with a bit of honey and then top with a dollop of butter and a sprinkling of salt.
6. Roast pears in the oven for approximately 18 to 20 minutes until tender to the touch. Set aside.

7. Heat olive oil in a large skillet over medium heat on the stove top.
8. When it reaches heat, add 2 tablespoons of the butter and melt.
9. Add onions. You are caramelizing the onions, so keep over medium or medium-low heat and gradually cook until tender and colored. Season well with kosher salt.
10. Remove from pan and set aside. Return pan to heat and add remaining 4 tablespoons of butter. Bring to foam stage and then allow to start browning. We are looking for browning of the solids. Be careful. Once it browns, remove from heat immediately.
11. Not over flame, add balsamic slowly and stir in to combine. It will bubble up and steam a bit so be careful. When combined in full, toss onions back in and toss to coat well with the balsamic butter. Remove from pan and set aside.

12. Roll out puff pastry sheet (store-bought or homemade) to a thickness of about ⅓ to ½ an inch.
13. Cut puff pastry into "tart shells" that are 6 inches long by 4 inches wide.
14. Lightly score a ½-inch border around interior edge of pastry with the tip of a sharp paring knife. This will help the center not over-rise and create a border.
15. Crack egg in a small bowl and beat with a drop or two of water, creating an egg wash.
16. Lightly brush border area of tart shell with the egg wash to help it brown.

17. On a parchment-lined sheet tray, assemble tarts: line bottom of each tart with 1-plus tablespoon of the balsamic brown butter onions and then lay down ½ a segment of pear (approximately 3 slices) fanned out in an overlapping row. Finish with approximately 1 to 2 tablespoon of shredded cheese.
18. Bake in an oven at 350 degrees for 15 or more minutes until crust is golden and set. Double-check by peeking under the center to make sure center of tart has baked through.
19. Finish before serving with a few shaves of the cheese.

Acorn Squash Moranga

Samba
7 Park Street, Montclair
montclairsamba.com

Yield: 4 servings

INGREDIENTS:

2 medium acorn squash

¼ cup extra virgin olive oil

2 medium white onions, diced

4 gloves of garlic, minced

1 medium butternut squash, diced

1 pint heavy cream

1 13.5-ounce can coconut milk

1 pound jumbo shrimp

parsley and cilantro for garnish

¼ cup shaved Parmesan cheese

DIRECTIONS:

1. Cut acorn squash in half and remove seeds, creating a bowl. Cover squash with aluminum foil and cook in an oven at 350 degrees until tender, about 1 hour or 1 hour and 15 minutes.
2. Heat extra virgin olive oil in a large skillet. Over medium heat, bloom the onion with garlic and caramelize the butternut squash. When squash is tender, add the heavy cream and coconut milk and simmer. Add the shrimp and cook for another 4 minutes.
3. Pour the cooked butternut squash and shrimp mixture into the acorn squash. Garnish with parsley and cilantro and top with shaved Parmesan.

Kohlrabi, Apple and Beetroot Salad

Josh Thomsen, executive chef at Agricola
11 Witherspoon Street, Princeton
agricolaeatery.com

Agricola serves this salad in the fall season when Great Road Farm is full of kohlrabi and beets. Make sure you save the beetroot leaves to add to the salad as lettuce. Serve this salad by itself or as a side to a simply roasted chicken or fish.
—Josh Thomsen

Kohlrabi, apple and beetroot salad at Agricola in Princeton. *Guy Ambrosino.*

Yield: 4 to 6 servings

INGREDIENTS:

2 large kohlrabi

3 apples (Agricola uses local Terhune Orchard apples)

2 medium beetroots

6 beetroot leaves, washed and torn into bite-size pieces

1.5 ounces cilantro leaves, roughly chopped, plus extra for garnish

1 garlic clove, crushed

1.5 ounces cider vinegar

2 ounces extra virgin olive oil

kosher salt and freshly ground black pepper

DIRECTIONS:

1. Peel the kohlrabi, cut in half and slice thinly by hand or a mandoline.
2. Peel and core the apples and then slice to the same thickness.
3. Peel the beetroot and grate coarsely on a box grater.
4. Mix together all the vegetables in a large bowl and then add the rest of the ingredients. Stir well, taste and season—you can afford to be generous with the salt.
5. Place on a serving plate and garnish with extra chopped cilantro.

ROASTED CAULIFLOWER

James Muir, consulting chef for Orale Mexican Kitchen
341 Grove Street, Jersey City
oralemk.com

INGREDIENTS:

2 heads cauliflower

extra virgin olive oil

kosher salt to taste

2 ounces panko crust (recipe following)

1 lime, cut into supremes, and the peel julienne

2 ounces toasted cashews

6 cilantro sprigs

2 ounces grapefruit vinaigrette (recipe following)

DIRECTIONS:

1. Cut the cauliflower into florets and toss in a bowl with the olive oil and salt to taste.
2. Spread on a sheet pan and roast at 375 degrees until lightly browned and cooked through.
3. Once roasted, the cauliflower can be kept cold until the following day. On a sheet pan, arrange the roasted cauliflower florets and crumble some of the panko crust over them, pressing it down onto the cauliflower. Roast at 375 degrees for 5 minutes or until the panko crust is golden brown. Transfer to a plate.
4. In a small stainless steel bowl, toss together the lime supremes and lime peel, the toasted cashews, the cilantro sprigs and the grapefruit vinaigrette. Then add to the cauliflower plate and serve.

For the Panko Crust

INGREDIENTS:
6 ounces panko breadcrumbs
8 ounces butter, softened
1¼ ounces Parmesan cheese

DIRECTIONS:
1. Blend all ingredients in a food processor.
2. Wrap into a log shape and freeze.

For the Grapefruit Vinaigrette

INGREDIENTS:
20 ounces ruby red grapefruit juice
5 ounces lime juice
¾ ounce honey
2¼ ounces sugar
2 teaspoon kosher salt
¼ teaspoon xanthan gum
6 ounces extra virgin olive oil

DIRECTIONS:
1. Reduce 16 ounces of grapefruit juice to 8 ounces.
2. Add the remaining 4 ounces of grapefruit juice along with the rest of the ingredients to a blender and blend for 2 minutes.
3. Refrigerate until needed.

CAVOLO NERO SALAD

Porta
911 Kingsley Street, Asbury Park
pizzaporta.com

Yield: 1 serving

INGREDIENTS:
4 cups loosely packed kale, chopped
¼ cup Parmesan cheese
6 to 8 slices watermelon radish
6 to 8 slices sunchoke
8 to 10 croutons (see recipe following)

DIRECTIONS:
1. Add all ingredients into a bowl and pour in 4 tablespoons of the Cavolo Nero dressing (recipe following). It should cling slightly to the kale.
2. Season with salt and then plate.

Cavolo Nero Crouton Marinade

INGREDIENTS:

1 cup lemon juice

1½ teaspoon minced garlic

1 tablespoon chili flakes

¾ cup olive oil

½ loaf ciabatta, cut into 1-inch cubes

DIRECTIONS:

1. In a blender, combine lemon, garlic and chili flakes and then slowly add olive oil to emulsify.
2. Marinate the ciabatta cubes for 5 to 10 minutes.
3. Bake at 500 degrees and rotate every 2 minutes until they get a light char on the edges without burning.

Cavolo Nero Dressing

INGREDIENTS:

¼ cup lemon juice

¼ cup olive oil

½ teaspoon minced garlic

¾ teaspoon honey

salt and pepper to taste

DIRECTIONS:

Blend all ingredients with whisk or blender.

ENDIVE CAESAR SALAD

Chef Francesco Palmieri, Orange Squirrel
412 Bloomfield Avenue, Bloomfield
theorangesquirrel.com

Yield: 4 servings

INGREDIENTS:

Mayonnaise

1 egg yolk

½ teaspoon salt

½ teaspoon dry mustard

2 teaspoons lemon juice

1 tablespoon white wine vinegar

1 cup vegetable oil

1 tablespoon fresh lemon juice, strained

1 tablespoon roasted garlic puree (roast and puree first)

1 tablespoon Worcestershire sauce

1 tablespoon white wine vinegar

½ cup fresh grated Parmesan, plus some for sprinkling on top of the finished salad

½ tablespoon salt

1 to 2 heads endive

1 package marinated white anchovies (approximately 12 total)

½ tablespoon fresh ground black pepper, more to taste

DIRECTIONS:

1. Make the mayonnaise. Whisk together the egg yolk, salt, mustard, lemon juice and vinegar. While whisking, slowly drizzle in oil to create an emulsion.
2. Once all oil is added and the mayo is fully emulsified, add the lemon juice, garlic, Worcestershire sauce, vinegar, parmesan and salt to the mayo.
3. Cut apart endive. Dress each leaf individually with dressing and then stack about a dozen endive leaves, starting with larger on bottom and smaller on top, in a crisscross pattern.
4. Top with three marinated white anchovies per salad.
4. Sprinkle grated cheese on top and cracked black pepper to taste.
5. Optional: Add thin bread croutons as a garnish.

New Jersey Farmers' Markets

D ates and times are subject to change. Please visit a market's website to confirm listing information before you venture out.

Atlantic County

Atlantic City Farmers' Market
Center City Park, 1200 Atlantic Avenue, Atlantic City
July–September, Thursdays and Saturdays, 9:00 a.m.–3:00 p.m.
njcrda.com

Brigantine Beach Farmers' Market
Haneman Park, Fifteenth Street and Revere Boulevard, Brigantine
May–September, Saturdays, 8:30 a.m.–noon
brigantinebeachgreenteam.com

Margate Farmers' Market
9700 Amherst Avenue (in the parking lot of Steve & Cookie's By the Bay
 Restaurant), Margate
June–September, Thursdays, 8:30 a.m.–2:00 p.m.
steveandcookies.com

BERGEN COUNTY

Allendale Farmers' Market
120 West Allendale Avenue (behind the clock tower), Allendale
June–October, Saturdays, 9:30 a.m.–2:30 p.m.
allendalechamber.com/farmersmkt

Englewood Farmers' Market
Depot Square Park, North Van Brunt Street and Demarest Avenue, Englewood
June–October, Fridays, 11:00 a.m.–6:00 p.m.

Fort Lee Farmers' Market
Jack Alter Fort Lee Community Center Plaza, 1355 Inwood Terrace, Fort Lee
June–November, Sundays, 8:00 a.m.–2:00 p.m.
fortleenj.org

Hasbrouck Heights Farmers' Market
Central Avenue and the Boulevard, Hasbrouck Heights
June–October, Tuesdays, noon–6:00 p.m.

Haworth Farmers' Market
Terrace Street, Haworth
June–September, Tuesdays, 2:00 p.m.–7:00 p.m.
haworthnj.org

Paramus Farmers' Market
Petruska Park, 475 Fairview Avenue, Paramus
June–September, Wednesdays, 2:00 p.m.–6:30 p.m.
paramusborough.org

Ramsey Farmers' Market
Summer
Ramsey train station parking lot, Main Street, Ramsey
June–November, Sundays, 9:00 a.m.–2:00 p.m.
Winter
Eric Smith School, 73 Monroe Street, Ramsey
December–March, Sundays, 10:00 a.m.–2:00 p.m.
ramseyfarmersmarket.org

Ridgewood Farmers' Market
New Jersey Transit railroad station, 6 Garber Square, Ridgewood
June–November, Sundays, 9:00 a.m.–3:00 p.m.
ridgewoodchamber.com

River Vale Farmers' Market
Summer
406 Rivervale Road, River Vale
June–October, Thursdays, noon–6:00 p.m.
Winter
Rivervale Community Center, 628 Rivervale Road, River Vale
November–March, biweekly Saturdays, 10:00 a.m.–2:00 p.m.
rivervalenj.org

Rutherford Farmers' Market
Williams Plaza, Park Avenue, Rutherford
June–October, Wednesdays, 11:00 a.m.–6:00 p.m.
July–October, Saturdays, 8:00 a.m.–2:00 p.m.
downtownrutherfordnj.com

Teaneck Farmers' Market
Cedar Lane municipal parking lot, Garrison Avenue and Beverly Road, Teaneck
June–October, Thursdays, noon–6:00 p.m.
cedarlane.net

BURLINGTON COUNTY

Bordentown City Community Farmers' Market
Carslake Community Center, 207 Crosswicks Street, Bordentown City
June–September, Wednesdays, 3:00 p.m.–dusk
bordentowncityfarmersmarket.com

Burlington County Farmers' Market
500 Centerton Road, Moorestown
May–October, Saturdays, 8:30 a.m.–1:00 p.m.
burlcoagcenter.com

Chesterfield Healthy Community Farmers' Market
Chesterfield Elementary School, Saddle Way, between Wright Drive and
 Thorn Lane, Chesterfield
June–September, Thursdays, 3:30–7:00 p.m.

Columbus Farmers' Market
2919 Route 206, Columbus
May–November, Thursdays–Sundays, 7:30 a.m.–3:00 p.m.
Produce Row, Wednesdays–Sundays, 7:00 a.m.–5:00 p.m.
columbusfarmersmarket.com

Delran's Farmers' Market
900 Chester Avenue, Delran
June–August, Tuesdays, 4:00 p.m.–8:00 p.m.
delrantownship.org

Kirby's Farmers' Market
67 North Main Street, Medford
June–October, Sundays, 10:00 a.m.–2:00 p.m.
kirbybros.com

United Communities McGuire Air Force Base Farmers' Market
Jim Saxon Community Center, Falcons Court North, McGuire Air Force Base
June–September, Thursdays, 10:00 a.m.–2:00 p.m.
facebook.com/FarmersMarketUC

Camden County

Berlin Farmers' Market
41 Clementon Road, Berlin
Year-round, Saturdays and Sundays, 8:00 a.m.–4:00 p.m.
berlinfarmersmarket.com

Blackwood Farmers' Market
Library parking lot, 15 South Black Horse Pike, Blackwood
June–September, Saturdays, 9:00 a.m.–1:00 p.m.
blackwoodfarmersmarket.webs.com

Camden Children's Garden Farmers' Market
3 Riverside Drive, Camden
April–October, Fridays and Sundays, 10:30 a.m.–3:00 p.m.; Saturdays, 9:00 a.m.–3:00 p.m.
camdenchildrensgarden.org

Collingswood Farmers' Market
Between Collins and Irvin Avenues, Collingswood
May–November, Saturdays, 8:00 a.m.–noon
collingswoodmarket.com

Haddonfield Farmers' Market
30 Kings Court, Haddonfield
May–October, Saturdays, 8:30 a.m.–1:00 p.m.
haddonfieldfarmersmarket.org

Haddon Heights Farmers' Market
Station and East Atlantic Avenues, Haddon Heights
May–October, Sundays, 10:00 a.m.–1:00 p.m.
hhfarmersmarket.com

Laurel Springs' Farmers' Market
Cord Mansion Greene, Tomlinson and West Atlantic Avenues, Laurel Springs
May–October, Saturdays, 10:00 a.m.–2:00 p.m.

Merchantville Farmers' Market
The Gazebo, Chestnut and Center Streets, Merchantville
June–November, first and third Saturdays, 9:00 a.m.–1:00 p.m.
merchantville.com/shop/farmers-market

Virtua Health Farmers' Market
1000 Atlantic Avenue, Camden
June–October, Thursdays, 11:00 a.m.–3:00 p.m.
camden-ahec.org

Voorhees Town Center's Farmers' Market
Somerdale and Burnt Mill Roads, Voorhees
May–October, Saturdays, 8:00 a.m.–noon
voorheestowncenter.com

Westmont Farmers' Market
Haddon and Stratford Avenues, Haddon Township
May–October, Wednesdays, 4:00 p.m.–7:00 p.m.
westmontfarmersmarket.com

Cape May County

Downtown Wildwood Farmers' Market
Schellenger and Pacific Avenues, Wildwood
June–August, Saturdays, 8:30 a.m.–1:00 p.m.
dowildwood.com

Ocean City Farmers & Crafters Market
Ocean City Tabernacle, Sixth Street and Asbury Avenue, Ocean City
June–September, Wednesdays, 8:00 a.m.–1:00 p.m.
oceancityvacation.com

Sea Isle City Farmers' Market
Excursion Park, JFK Boulevard and Pleasure Avenue, Sea Isle City
June–August, Tuesdays, 8:00 a.m.–1:00 p.m.
seaislechamber.com

Stone Harbor Farmers' Market
Water Tower parking lot, Ninety-fifth Street and Second Avenue, Stone Harbor
June–September, Sundays, 8:00 a.m.–12:30 p.m.
stoneharborbeach.com

West Cape May Farmers' Market
Backyard Park at Borough Hall, 732 Broadway, West Cape May
June–August, Tuesdays, 3:00 p.m.–7:30 p.m.
westcapemay.us

CUMBERLAND COUNTY

Marlboro Farm Market at the Greater Bridgeton Amish Market
2 Cassidy Court, Bridgeton
Year-round, Thursdays, 9:00 a.m.–6:00 p.m.; Fridays, 9:00 a.m.–7:00 p.m.;
 Saturdays, 9:00 a.m.–4:00 p.m.

ESSEX COUNTY

Bloomfield Farmers' Market
Venner Park, Bloomfield Avenue between State and Liberty Streets, Bloomfield
July–October, Thursdays, 1:00 p.m.–7:00 p.m.
bloomfieldcenter.com

The Commons at Washington Park Farmers' Market
Washington and James Streets, Newark
June–October, Wednesdays, 11:00 a.m.–3:00 p.m.
nourishingnewarkfarmersmarkets.org

Downtown West Orange Alliance Farmers' Market
Quigley municipal lot, Eagle Rock and Harrison Avenues, West Orange
June–October, Fridays, noon–6:00 p.m.
westorange.org

Maplewood Farmers' Market
Municipal lot, Indiana Street and Springfield Avenue, Maplewood
June–October, Mondays, 2:00 p.m.–7:00 p.m.
twp.maplewood.nj.us/index.aspx?nid=510

Millburn Farmers' Market
Municipal lot, Main and Essex Streets, Millburn
June–November, Tuesdays, 9:00 a.m.–3:00 p.m.
downtownmillburn.org

Montclair Farmers' Market
Walnut Street train station, 25 Depot Square, Montclair
Year-round, June–November, Saturdays, 8:00 a.m.–2:00 p.m.
Underground Winter Market, Saturdays, 9:00 a.m.–1:00 p.m.

Montclair Farmers' Market 2.0 @ Montclair Center
South Park Street, Montclair
June–November, Tuesdays, 1:00 p.m.–7:00 p.m.

NDD Common Greens Farmer's Market
PSE&G Plaza, 80 Park Place, Newark
June–November, Thursdays, 11:00 a.m.–3:00 p.m.
downtownnewark.com

Nutley Farmers' Market
Municipal lot, Franklin Avenue and William Street, Nutley
June–October, Sundays, 9:00 a.m.–2:00 p.m.
nutleynj.org

Roseland Farmers' Market
Roseland and Harrison Avenues, Roseland
June–November, Fridays, noon–6:00 p.m.
roselandmarket.org

South Orange Farmers' Market
Municipal lot 9, First and Sloan Streets, South Orange
June–October, Wednesdays, 2:00 p.m.–7:00 p.m.
sovillagecenter.org

The University Hospital Auxiliary's Farmers' Market
UMDNJ Plaza, Twelfth Avenue near Norfolk Street, Newark
June–October, Tuesdays, 10:00 a.m.–3:00 p.m.
nourishingnewarkfarmersmarkets.org

GLOUCESTER COUNTY

No markets at this time

HUDSON COUNTY

Bayonne Farmers' Market
Twenty-third Street and Del Monte Drive, Bayonne
May–October, Tuesdays, 2:00 p.m.–7:00 p.m.
facebook.com/BayonneFarmersMarket

Farmers' Market at Lincoln Park
Lincoln Park gazebo, West Side Avenue at Belmont Avenue, Jersey City
June–November, Sundays, 10:00 a.m.–3:00 p.m.
facebook.com/FarmersMarketatLincolnPark

Garden Street Farmers' Market
Garden and Fourteenth Streets, Hoboken
June–November, Saturdays, 9:00 a.m.–2:00 p.m.
hobokennj.org/departments/environmental-services/farmers-market
gardenstreetfarmersmarket.com

Hamilton Park Farmers' Market
Hamilton Park, Eighth Street between West Hamilton and McWilliams
 Place, Jersey City
April–December, Wednesdays, 3:00 p.m.–7:30 p.m.
facebook.com/HPNAFarmersMarket

Historic Downtown Special Improvement District's Farmers' Market
Grove Street PATH Plaza, Jersey City
May–December, Mondays and Thursdays, 4:00 p.m.–8:00 p.m.
jcdowntown.org

Hoboken Downtown Market Farmers' Market
Newark and Washington Streets, Hoboken
June–November, Tuesdays, 3:00 p.m.–7:30 p.m.
hobokennj.org/departments/environmental-services/farmers-market
hobokenfarmersmarket.com/DowntownAbout.htm

Hoboken Uptown Market
Hudson and Thirteenth Streets, Hoboken
June–October, Thursdays, 2:00 p.m.–7:00 p.m.
hobokennj.org/departments/environmental-services/farmers-market
hobokenfarmersmarket.com/UptownAbout.htm

Journal Square Farmers' Market
Kennedy Boulevard at Journal Square, Jersey City
June–November, Wednesdays and Fridays, 11:00 a.m.–6:30 p.m.
loewsjersey.org

Kearny Farmers' Market
Kearny Avenue, Kearny
June–October, Thursdays, noon–6:00 p.m.
kearnynj.org

Riverview Farmers' Market
Riverview-Fisk Park, Palisades Avenue between Bowers and Griffith Streets,
 Jersey City
May–November, Sundays 9:00 a.m.–2:00 p.m.
riverviewfarmersmarket.org

Union City Farmers' Market at Troy Towers
380 Mountain Road, north parking lot, Union City
May–December, Sundays, 9:00 a.m.–2:00 p.m.
troytowers.net

Van Vorst Park Farmers' Market
Jersey Avenue and Montgomery Street, Jersey City
April–December, Saturdays, 8:30 a.m.–3:00 p.m.
fvvp.org

HUNTERDON COUNTY

Clinton Farmers' Market
Clinton Fire Company parking lot, 1 New Street, Clinton
May–October, Sundays, 9:00 a.m.–1:00 p.m.

Frenchtown Farmers' Market
Frenchtown (check website for new location and times)
frenchtownnj.org

Holland Township Farmers' Market
Holland Township Fire Co., 971 Milford-Warren Glen Road (Route 519), Milford
June–September, Saturdays, 9:00 a.m.–1:00 p.m.

Hunterdon Land Trust Farmers' Market
The Dvoor Farm, 111 Mine Street, Flemington
May–November, Sundays, 9:00 a.m.–1:00 p.m.; monthly winter market, December–April, 11:00 a.m.–1:00 p.m.
hunterdonlandtrust.org

Sergeantsville Farmers' Market
Routes 523 and 604, Sergeantsville
May–October, Saturdays, 8:30 a.m.–noon
sergeantsfarmersmarket.com

Stangl Factory Farmers' Market
Mine Street and Stangl Road, Flemington
Year-round, Saturdays, 9:00 a.m.–3:00 p.m.
stanglfactory.com

Stockton Farmers' Market
19 Bridge Street, Stockton
Year-round; Fridays, 3:00 p.m.–7:00 p.m., Saturdays, 9:00 a.m.–4:00 p.m.; and Sundays, 10:00 a.m.–4:00 p.m.
stocktonfarmmarket.com

MERCER COUNTY

Capital City Farmers' Market
Mill Hill Park, between Front and Broad Streets, Trenton
July–October
destinationtrenton.com

Hightstown Farmers' Market
Memorial Park, Stockton Street, Hightstown
June–September, Fridays, 5:00 p.m.–8:00 p.m.
downtownhightstown.org

Hopewell Community Farmers' Market
17 Railroad Avenue, Hopewell
Year-round, Wednesdays, 3:00 p.m.–6:00 p.m.
highlandmarket.com

Pennington Farmers' Market
Rosedale Mills, 101 Route 31, Pennington
June–November, Saturdays, 9:00 a.m.–1:00 p.m.
penningtonfarmersmarket.org

Princeton Farmers' Market
Hinds Plaza, 55 Witherspoon Street, Princeton
May–November, Thursdays, 11:00 a.m.–4:00 p.m.

Princeton Forrestal Village Farmers' Market
2 Village Boulevard, Princeton
June–September, Fridays, 11:00 a.m.–2:00 p.m.
facebook.com/ForrestalVillageFarmersMarket

Princeton Winter Market
Inside Princeton Public Library, 65 Witherspoon Street, Princeton
December–April, every second Thursday, 11:00 a.m.–4:00 p.m.
princetonfarmersmarket.com

Robbinsville Farmers' Market
Parking lot on the corner of Route 526 and Highway 33, Robbinsville
June–September, Mondays, 3:00 p.m.–7:30 p.m.

Trenton Farmers' Market
960 Spruce Street, Trenton
January–April, Thursdays–Saturdays, 9:00 a.m.–6:00 p.m.
May–October; Wednesdays–Saturdays, 9:00 a.m.–6:00 p.m.; Sundays, 10:00 a.m.–4:00 p.m.
November–December; Thursdays–Saturdays, 9:00 a.m.–6:00 p.m.; Sundays, 10:00 a.m.–3:00 p.m.
Extended hours prior to Easter, Thanksgiving, Christmas and New Years Day
thetrentonfarmersmarket.com

Wednesday on Warren
Curbside, South Warren Street between East State and LaFayette Streets,
 Trenton
May–June, Wednesdays, 11:30 a.m.–2:30 p.m.
destinationtrenton.com

West Windsor Community Farmers' Market
Princeton Junction train station, Vaughn Drive commuter lot off Alexander
 Road, West Windsor
May–November, Saturdays, 9:00 a.m.–1:00 p.m.
westwindsorfarmersmarket.org

Middlesex County

Edison Farmers' Market
925 Amboy Avenue, Edison
June–October, Sundays, 8:00 a.m.–2:00 p.m.
edisonnj.org/farmersmarket

Highland Park Farmers' Market
218 Raritan Avenue (Route 27) between South Second and Third Avenues,
 Highland Park
June–November, Fridays, 11:00 a.m.–5:30 p.m.
mainstreethp.org

Kendall Park Farmers' Market
Christ the King Lutheran Church, 3330 Route 27, Kendall Park
May–September, Wednesdays, 2:00 p.m.–7:00 p.m.
xtheking.org/ministries/kendallparkfarmersmarket.html

Metuchen Farmers' Market
New Street, Metuchen
June–November, Saturdays, 9:00 a.m.–2:00 p.m.
metuchenfarmersmarket.com

New Brunswick Community Farmers' Markets
Cook Campus, 56 Nichol Avenue, New Brunswick

September–October, Thursdays, 11:00 a.m.–3:00 p.m.
nbcfarmersmarket.com

New Brunswick Community Farmers' Markets
Downtown at Kilmer Square, 108 Albany Street, New Brunswick
June–October, Wednesdays, 11:00 a.m.–3:00 p.m.
nbcfarmersmarket.com

New Brunswick Community Farmers' Markets
Pavilion and Gardens, 178 Jones Avenue, New Brunswick
June–November, Saturdays, 10:00 a.m.–3:00 p.m.; June–August, Thursdays,
 11:00 a.m.–3:00 p.m.
nbcfarmersmarket.com

Old Bridge Fresh Market
Mannino Park, Mannino Drive and Route 516, Old Bridge
May–October, Fridays, 11:00 a.m.–6:00 p.m.
obfreshmarket.com

Rutgers Gardens Farmers' Market
Rutgers Gardens, 112 Ryders Lane, New Brunswick
May–November, Fridays, 11:00 a.m.–5:00 p.m.; December, Fridays,
 11:00 a.m.–4:00 p.m.
rutgersgardens.rutgers.edu/farmmarket.htm

Woodbridge Wednesdays Farmers' Market
Parker Press Park, 400 Rahway Avenue, Woodbridge
June–September, Wednesdays, 3:00 p.m.–8:30 p.m.
twp.woodbridge.nj.us

MONMOUTH COUNTY

Asbury Fresh
Kennedy Park, corner of Cookman and Grand Avenues, Asbury Park
June–September, Sundays, 11:00 a.m.–4:00 p.m.
asburyfresh.com

Asbury Park Farmers' Market
Firemen's Park, Main and Sunset Avenues, Asbury Park
May–October, Saturdays, 8:00 a.m.–1:00 p.m.
facebook.com/APSUNSETMARKET

Atlantic Highlands Chamber of Commerce Farmers' Market
Veteran's Park, opposite Borough Hall, First Avenue, Atlantic Highlands
June–October, Fridays, noon–6:00 p.m.
atlantichighlands.org

Belmar Farmers' Market
Pyanoe Plaza, Ninth Avenue and Main Street, Belmar
May–September, Saturdays, 9:00 a.m.–2:00 p.m.
visitbelmarnj.com

Downtown Freehold Farmers' Market
Hall of Records, 1 East Main Street, Freehold
July–October, Fridays, 11:00 a.m.–3:00 p.m.
downtownfreehold.com

Englishtown Auction and Farmers' Market
County Road 527, Englishtown
Year–round, Saturdays and Sundays, 8:00 a.m.–4:00 p.m.

Giamano's Farmers' Market
301 Main Street, Bradley Beach
June–October, Wednesdays, 11:00 a.m.–4:00 p.m.
giamanos.com

Highlands Farmers' Market
Huddy Park, corner of Shore and Waterwitch, Highlands
June–November, Saturdays, 8:30 a.m.–2:00 p.m.
highlandsnj.com

Keyport Farmers' Market
Fireman's Park, West Front Street, Keyport
June–October, Thursdays, 1:00 p.m.–7:00 p.m.
visitkeyport.org

Manasquan Farmers' Market
Corner of Main Street and Miller Preston Way, Manasquan
July–August, Thursdays, 10:00 a.m.–3:00 p.m.
manasquanchamber.org

Red Bank Farmers' Market
The Galleria parking lot, Bridge Avenue and West Front Street, Red Bank
May–November, Sundays, 9:00 a.m.–2:00 p.m.
TheGalleriaRedBank.com

Sea Bright Farmers' Market
Municipal lot, Ocean Avenue, Sea Bright
May–September, Thursdays, 2:00 p.m.–7:00 p.m.
facebook.com/SeaBrightFarmersMarket

West End Farmers' Market
Corner of Brighton and Kossik Avenue, Long Branch
June–November, Thursdays, 11:00 a.m.–6:00 p.m.

MORRIS COUNTY

Boonton Farmers' Market
Upper Plane Street parking lot, 808 Main, Boonton
June–November, Saturdays, 8:30 a.m.–2:00 p.m.
BoontonMainStreet.org

Chatham Borough Farmers' Market
Railroad Plaza, south off Fairmount Avenue, Chatham
June–November, Saturdays, 8:00 a.m.–1:00 p.m.
chathamborough.org

Chester Farmers' Market
Perry Street, Chester
June–October, Sundays, 10:00 a.m.–3:00 p.m.
chesternjfarmersmarket.org

Denville Farmers' Market
Bloomfield Avenue parking lot, visible from Route 46, Denville
June–November, Sundays, 8:30 a.m.–1:00 p.m.; December–May, every
 other Sunday, 10:00 a.m.–1:00 p.m.
denvillefarmersmarket.com

East Hanover Farmers' Market
Lurker Park, 609 Ridgedale Avenue, East Hanover
June–October, Mondays, noon–6:00 p.m.
easthanovertownship.com

Long Valley Green Market
20 Schooley's Mountain Road, Long Valley
April–December, Thursdays, 3:00 p.m.–7:00 p.m.
longvalleygreenmarket.com

Madison Farmers' Market
Corner of Green Village Road and Main Street, Madison
June–October, Thursdays, 1:00 p.m.–6:00 p.m.

Mendham Farmers' Market
1 Cold Hill Street, Mendham Township
June–October, Saturdays, 9:00 a.m.–1:00 p.m.

Morris Plains Farmers' Market
Speedwell Avenue Extension, Merchant Block, Morris Plains
June–October, Saturdays, 9:00 a.m.–2:00 p.m.
morrisplainsboro.org

Morristown Farmers' Market
Spring Street and Morris Street, Morristown
June–November, Sundays, 8:30 a.m.–2:00 p.m.
morristown-nj.org

Pequannock Farmers' Market
Town Hall Field, Pequannock
June–September, Thursdays, 2:00 p.m.–7:00 p.m.
peqtwp.org

Riverdale Farmers' Market
211 Hamburg Turnpike, Riverdale
June–October, Tuesdays, 2:30 p.m.–7:00 p.m.
facebook.com/riverdalefarmersmarket

OCEAN COUNTY

Barnegat Farmers' Market
Corner of East Bay Avenue and Route 9, Barnegat
June–October, Thursdays, noon–5:00 p.m.

Downtown Toms River Farmers' Market
Southeast corner of West Water and Irons Streets, Toms River
May–November, Wednesdays, 11:00 a.m.–5:00 p.m.
downtowntomsriver.com/bid/market.htm

Point Pleasant Beach Farmers' Market
601 Arnold Avenue and Route 35 South (Borden's parking lot), Point
 Pleasant Beach
June–September, Sundays, 10:00 a.m.–2:00 p.m.
www.facebook.com/PointPleasantBeachFarmersMarket

Seaside Park Farmers' Market
J Street and Central Avenue (Marina Lawn), Seaside Park
September–October, Sundays, 11:00 a.m.–4:00 p.m.

Stafford Township Farmers' Market
657 East Bay Avenue (held at the Manahawkin Flea Market), Manahawkin
July–September, Fridays, 9:00 a.m.–3:00 p.m.

Tuckerton Farmers' Market
120 West Main Street (Route 9), Tuckerton
June–September, Saturdays, 9:00 a.m.–1:00 p.m.

Passaic County

Hawthorne Farmers' Market
Grand Avenue (behind the library), Hawthorne
June–October, Sundays, 9:00 a.m.–2:00 p.m.
facebook.com/pages/Hawthorne-Farmers-Market/195160677173011

Little Falls ABC Farmers' Marketplace & More
Main Street and First Avenue, Memorial Park, Little Falls
June–August, Thursdays, 5:00 p.m.–8:30 p.m.
littlefallsabc.org

Paterson Farmers' Market
449 East Railway Avenue, Paterson
Year-round, Saturdays and Sundays, 6:00 a.m. until sold out
patersonfarmersmarket.com

Ringwood Farmers' Market
Ringwood Park & Ride, Cannici Drive and Skyline Drive, Ringwood
May–October, Saturdays, 9:00 a.m.–1:00 p.m.
RingwoodFarmersMarket.org

West Milford Farmers' Market
West Milford Presbyterian Church parking lot, West Milford
June–October, Wednesdays, 3:00 p.m.–7:00 p.m.
wmfarmersmarket.org

Salem County

Salem Farmers' Market
East Broadway, Salem
June–August, Thursdays, 10:00 a.m.–2:00 p.m.
salemcitynj.com/16001.html

SOMERSET COUNTY

Bernardsville Farmers' Market
Route 202 and Claremont Road, Bernardsville
June–November, Saturdays, 9:00 a.m.–noon

Bound Brook Farmers' Market
Main Street, Bound Brook
June–October, Saturdays, 9:00 a.m.–2:00 p.m.
facebook.com/BoundBrookFarmersMarket

Branchburg Farmers' Market
2088 South Branch Road, Branchburg
June–September, Saturdays, 9:00 a.m.–2:00 p.m.
branchburgfarmersmarket.com

Downtown Somerville Farmers' Market
Division Street Plaza at West Main Street, Somerville
June–November, Thursdays, noon–7:00 p.m.
facebook.com/pages/Somerville-Downtown-Farmers-Market/99232302470

Farm to Table Market at Duke Farms
1112 Duke Parkway West, Hillsborough
June–November, Saturdays, 10:00 a.m.–3:00 p.m.
dukefarms.org

Manville Farmers' Market
Main Street, Manville
June–October, Fridays, 1:00 p.m.–6:00 p.m.

Montgomery Friends of Open Space Farmers' Market
Village Shopper parking lot, 1340 Route 206, Skillman
June–October, Saturdays, 9:00 a.m.–1:00 p.m.
montgomeryfriends.org/farmers-market

North Plainfield Farmers' Market
264 Somerset Street, North Plainfield
July–October, Saturdays, 9:00 a.m.–2:00 p.m.
facebook.com/NorthPlainfieldFarmersMarket

SMC Farmers' Market
30 Rehill Avenue, Somerville
June–September, Mondays, 2:00 p.m.–6:00 p.m.

SUSSEX COUNTY

Olde Lafayette Village Farmers' Market
75 State Route 15, Olde Lafayette Village, Lafayette
July–October, Sundays, 10:30 a.m.–3:00 p.m.

Sparta Farmers' Market
Sparta Health & Wellness Center parking lot, 89 Sparta Avenue, Sparta
June–October, Saturdays, 9:00 a.m.–1:00 p.m.
spartafarmersmarket.org

Sussex County Farmers' Market at the Fairgrounds
37 Plains Road, Barn Building, Augusta
June–October, Saturdays, 9:00 a.m.–2:00 p.m.
facebook.com/SussexCountyFarmersMarket

Winter Farmers' Market at Sparta
Sparta Middle School, 350 Main Street, Sparta
November–April, Saturdays, 10:00 a.m.–1:00 p.m.
winterfarmersmarketatsparta.com

UNION COUNTY

Elizabeth Avenue Farmers' Market at Union Square
Union Square Plaza, 1 High Street, Elizabeth
June–November, Tuesdays, 10:00 a.m.–6:00 p.m.
elizabethavenue.org

Liberty Hall Museum Community Farmers' Market
1003 Morris Avenue, Union

May–August, Thursdays, noon–6:00 p.m.; September–October, Thursdays, 11:00 a.m.–5:00 p.m.
facebook.com/libertyhallfarmersmarket

New Providence Farmers' Market
1307 Springfield Avenue, New Providence
June–October, Wednesday, noon–6:00 p.m.
facebook.com/NewProvidenceFarmersMarket

Rahway Farmers' Market
East Milton Avenue (Rahway train station), Rahway
May–November, Thursdays, noon–7:00 p.m.

Roselle Park Farmers' Market
Michael Mauri Park, located on corner of Chestnut Street and East Grant Avenue, Roselle
July–October, Wednesdays, 1:00 p.m.–6:00 p.m.

Scotch Plains Farmers' Market
430 Park Avenue, municipal parking lot, Scotch Plains
May–November, Saturdays, 8:00 a.m.–2:00 p.m.
facebook.com/ScotchPlainsFarmersMarket

Summit Farmers' Market
Maple Street and DeForest Avenue, Park & Shop, Lot No. 2, Summit
May–November, Sundays, 8:00 a.m.–1:00 p.m.
summitdowntown.org/events/events/summit-farmers-market
facebook.com/SummitFarmersMarket

Township of Springfield Farmers' Market
226 Morris Avenue, Springfield
July–August, Mondays, noon–6:00 p.m.
springfieldfarmersmarket.wordpress.com

Westfield Farmers' Market
South Avenue train station, Westfield
July–October, Saturdays, 8:30 a.m.–2:00 p.m.
westfieldareachamber.com/uncategorised/farmers-market

WARREN COUNTY

Blairstown Farmers' Market
Route 521, next to the Agway, across from the Blairstown Elementary School, Blairstown
June–October, Saturdays, 10:00 a.m.–2:00 p.m.
blairstownfarmersmarket.com

Moore Street Farmers' Market
Between Main and Washington at gazebo, Hackettstown
June–September, Saturdays, 10:00 a.m.–2:00 p.m.

Washington Borough Farmers' Market
East Washington Avenue, Washington
June–October, Fridays, 3:00 p.m.–7:00 p.m.
facebook.com/WashingtonBoroughNJFarmersMarket

Bibliography

Alford, Jeffrey, and Naomi Duguid. *Hot Sour Salty Sweet: A Culinary Journey through Southeast Asia*. New York: Artisan, 2000.

Bastianich, Lidia. *Lidia Cooks from the Heart of Italy: A Feast of 175 Regional Recipes*. New York: Knopf, 2009.

Bauer, Jeni Britton. *Jeni's Splendid Ice Creams at Home*. New York: Artisan, 2011.

Beard, James. *James Beard's American Cookery*. New York: Little, Brown and Company, 1972.

Berley, Peter. *The Flexitarian Table: Inspired, Flexible Meals for Vegetarians, Meat Lovers, and Everyone in Between*. Boston, MA: Rux Martin/Houghton Mifflin Harcourt, 2014.

Burks, Justin Fox, and Amy Lawrence. *The Southern Vegetarian Cookbook: 100 Down-Home Recipes for the Modern Table*. Nashville, TN: Thomas Nelson, 2013.

Child, Julia. *Mastering the Art of French Cooking*. New York: Alfred A. Knopf, 1961.

Child, Julia, and Jacques Pepin. *Julia and Jacques Cooking at Home*. New York: Alfred A. Knopf, 1999.

Dweck, Poopa. *Aromas of Aleppo: The Legendary Cuisine of Syrian Jews*. New York: Ecco, 2007.

Flay, Bobby. *Bobby Flay's Bar Americain Cookbook: Celebrate America's Great Flavors*. New York: Clarkson Potter, 2011.

Fussell, Betty. *Crazy for Corn*. New York: Perennial, 1995.

Gapultos, Marvin. *The Adobo Road Cookbook: A Filipino Food Journey— From Food Blog, to Food Truck, and Beyond*. North Clarendon, VT: Tuttle Publishing, 2013.

Gerson, Fany. *My Sweet Mexico: Recipes for Authentic Pastries, Breads, Candies, Beverages, and Frozen Treats.* Berkeley, CA: Ten Speed Press, 2010.

Harris, Jessica B. *The Africa Cookbook: Tastes of a Continent.* New York: Simon & Schuster, 1998.

Hirsheimer, Christopher, and Melissa Hamilton. *Canal House Cooking.* Vol. 6, *The Grocery Store.* Lambertville, NJ: Canal House, 2011.

Jinich, Pati. *Pati's Mexican Table: The Secrets of Real Mexican Home Cooking.* Boston, MA: Rux Martin/Houghton Mifflin Harcourt, 2013.

Keller, Thomas, and Sebastien Rouxel. *Bouchon Bakery.* New York: Artisan, 2012.

Khoo, Rachel. *The Little Paris Kitchen: 120 Simple but Classic French Recipes.* San Francisco, CA: Chronicle Books, 2013.

Kosmas, Jason, and Justin Zaric. *Speakeasy: The Employees Only Guide to Classic Cocktails Reimagined.* Berkeley, CA: Ten Speed Press, 2010.

Lo, Eileen Yin-Fei. *Mastering the Art of Chinese Cooking.* San Francisco, CA: Chronicle Books, 2009.

Marrone, Teresa. *The Beginner's Guide to Making and Using Dried Foods: Preserve Fresh Fruits, Vegetables, Herbs, and Meat with a Dehydrator, a Kitchen Oven, or the Sun.* North Adams, MA: Storey Publishing, LLC, 2014.

McClellan, Marisa. *Preserving by the Pint: Quick Seasonal Canning for Small Spaces from the Author of Food in Jars.* N.p.: Running Press, 2014.

The Moosewood Collective. *Moosewood Restaurant Low Fat Favorites: Flavorful Recipes for Healthful Meals.* New York: Clarkson Potter, 1996.

Morgan, Diane. *Roots: The Definitive Compendium with More than 225 Recipes.* San Francisco, CA: Chronicle Books, 2012.

Nguyen, Andrea. *Into the Vietnamese Kitchen: Treasured Foodways, Modern Flavors.* Berkeley, CA: Ten Speed Press, 2006.

Richardson, Julie. *Vintage Cakes: Timeless Recipes for Cupcakes, Flips, Rolls, Layer, Angel, Bundt, Chiffon, and Icebox Cakes for Today's Sweet Tooth.* Berkeley, CA: Ten Speed Press, 2012.

Terry, Bryant. *Vegan Soul Kitchen: Fresh, Healthy, and Creative African-American Cuisine.* Cambridge, MA: Da Capo Press, 2009.

West, Kevin. *Saving the Season: A Cook's Guide to Home Canning, Pickling and Preserving.* New York: Knopf, 2013.

Willis, Virginia. *Bon Appétit, Y'all: Recipes and Stories from Three Generations of Southern Cooking.* Berkeley, CA: Ten Speed Press, 2010.

Winslow, Kate, and Fabrizia Lanza. *Coming Home to Sicily: Seasonal Harvests and Cooking from Case Vecchie.* New York: Sterling Epicure, 2012.

BLOGS AND WEBSITES

agrilicious.org
bbcgoodfood.com
bellviewwinery.wordpress.com
bhg.com
bonappetit.com
chow.com
chubbyvegetarian.blogspot.com
cocktailwhisperer.com
cooksinfo.com
cuesa.org
delish.com
dinewithpat.com
doriegreenspan.com
eatbydate.com
eatdrinkadventure.com
emikodavies.com
epicurious.com
food.com
foodandwine.com
food52.com
foodinjars.com
freshfromzone7.com
fruitsandveggiesmorematters.org
gardenandgun.com
gourmet.com
grubstreet.com
jamieshomecookingskills.com
jerseyfresh.nj.gov
jerseypeaches.com
joythebaker.com
kingsfoodmarkets.com
laylita.com
localpalatemag.com

lunch.thecanalhouse.com
marthastewart.com
myrecipes.com
nationalkaleday.org
njfarmmarkets.org
njfb.org
njskylands.com
njspice.net
njveggies.org
101cookbooks.com
patismexicantable.com
pineypower.com
realsimple.com
realtimefarms.com
robsonsfarm.com
sanjeevkapoor.com
saveur.com
savingtheseason.com
scotsman.com
simplyrecipes.com
splendidtable.org
smittenkitchen.com
tarladalal.com
tastebook.com
terhuneorchards.com
thekitchn.com
usda.gov
vegetariantimes.com
vegrecipesofindia.com
vietworldkitchen.com
visitnjfarms.org
yummly.com

Index

About the Author

A native of the Jersey Shore, Rachel J. Weston is a food writer, chef and culinary instructor. She is committed to helping people understand their food system. Her passion is making seasonal, globally inspired meals from foods produced locally. Her work has been published online at NJ.com and in print in the *Star-Ledger*, *South Jersey Times*, the *Trenton Times* and the *Express-Times*. Nothing makes her happier than mucking about in a field with a farmer, peeking under a simmering pot's lid or shining a light on a small artisan food business.

Saed Hindash Photography.

For more information, or to sign up for her newsletter, "Cooking with Rachel Weston," visit www.racheljweston.com.